SURREY RAILWAY STATIONS

THROUGH TIME

Douglas d'Enno

AMBERLEY

Picture Credits

As in the case of Sussex, much of the early pictorial material was kindly made available by Laurie Marshall of Hove from his substantial collection. All of the remainder are from the author's own collection and camera, save for the following, acknowledged by contributor: G. R. Weddell (Brookwood Cemetery, North Station, page 6 upper), J. Scrace (Bingham Road, page 22), J. B. Gent coll. (Woodside, page 26 upper), the Station Pub, South Nutfield (Nutfield, page 28 upper), Terry Gough (Dorking West, page 34 upper), Robert Warner, Vice-President/Production Editor, Bourne Society (Caterham, page 39 upper), Barry Pepper and Rupert Courtenay-Evans (Chipstead, page 42 upper), Peter Reed/Epsom & Ewell Local and Family History Centre and Jeremy Harte/Bourne Hall Museum (Epsom, page 61 upper), Dave Hennegan (Box Hill, page 69 upper), Sunil Prasannan (Weybridge, page 82 lower) and George Papanicola (Barnes, page 88 upper).

Permission from Surrey County Council to reproduce the railway map on page 96 is acknowledged with thanks.

I sincerely apologise to any person or organisation inadvertently omitted.

First published 2017

Amberley Publishing
The Hill, Stroud, Gloucestershire, GL5 4EP
www.amberley-books.com

Copyright © Douglas d'Enno, 2017

The right of Douglas d'Enno to be identified as the Author of this work has been asserted in accordance with the Copyrights, Designs and Patents Act 1988.

ISBN 978 1 4456 5569 7 (print)
ISBN 978 1 4456 5570 3 (ebook)

British Library Cataloguing in Publication Data.
A catalogue record for this book is available from the British Library.

Typesetting by Amberley Publishing.
Printed in Great Britain.

Contents

Introduction

Railway stations are fascinating places. This I learned from online and paper research and when visiting those across Sussex for my *Sussex Railway Stations Through Time* (published by Amberley in 2016) well before my tour of Surrey, during which I travelled to the same number of stations (eighty-nine).

Surrey's station houses display varied architectural styles (witness the 'Tudoresque Gothicism' at Barnes and the Art Deco creations at Richmond, Surbiton and Wimbledon), embody novel commercial solutions (through, for example, being rebuilt within larger office premises, such as Biwater House, Dorking, Leo House, Wallington, and Station House, Camberley) and provide sometimes unusual retail/business opportunities (a hairdressing academy is based in the station house at Bagshot). At many locations, the past usefully lives on: in Mitcham, the station building of 1855 has survived as Station Court and is currently used in part – and owned in full – by Mitcham Physio. Goods yards have become packed car parks and coal merchants' huts, taxi offices.

Some of the county's stations, and their users, have suffered badly: at New Malden, on 16 August 1940, passengers disembarking from a Wimbledon–Kingston train were machine-gunned by low-flying aircraft. A Dornier 217 attacked a train carrying Christmas shoppers as it was leaving Bramley Station on 16 December 1942. The driver and guard lost their lives, a number of passengers were killed or wounded, and the train was badly damaged. At Tattenham Corner on 1 December 1993, an intoxicated driver (later jailed) embedded his train in the wooden booking office, which was demolished and rebuilt – in brick. In fiction at least, Woking Station was totally destroyed by H. G. Wells in his *The War of the Worlds*.

The Surrey forming the subject of this book is the county as it existed prior to the changes of 1965 and 1974. This is because the early stations depicted – predominantly on commercial postcards – all predate those years of boundary/administrative alteration.

It is hoped that this second helping of southern stations 'then and now' will be enjoyed just as much as my well-received Sussex volume, whose format it closely follows.

Douglas d'Enno
Saltdean, June 2017

Lost and Resited Stations

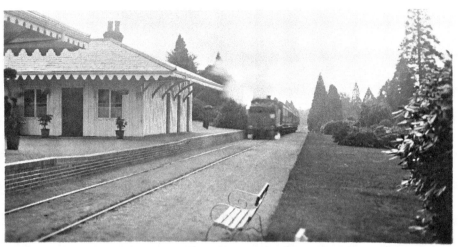

S.2409. THE STATION. BROOKWOOD CEMETERY.

The railway in a cemetery (1): The Necropolis Company's North Station

In 2005, Network Rail supplied and laid a – now overgrown – section of track close to the south-east exit of Brookwood Station. It commemorated the cemetery railway which operated here from 1854 to 1941 to alleviate the problem of the overcrowding of cemeteries in the capital. The funeral trains of the London Necropolis Company (the original owners of Brookwood Cemetery) ran from a private station just outside Waterloo, down the main line and into the cemetery. The first train arrived on 13 November 1854, when the cemetery was opened to the public. The service operated until the night of 16/17 April 1941 when the private terminus in London was largely destroyed by enemy action.

Above is an early twentieth century view of the North Station (demolished in the 1950s, with no trace remaining). The surviving low platform wall (*below*) is wired off at the foot of a tall coniferous hedge in Railway Avenue.

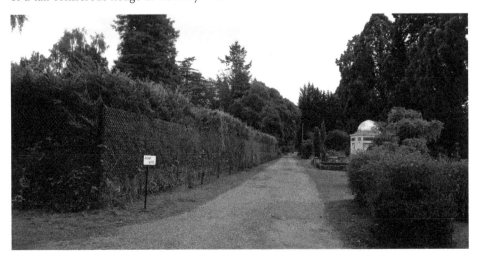

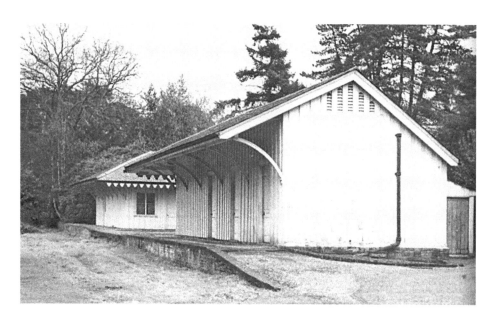

The railway in a cemetery (2): The Necropolis Company's South Station

By contrast, a well-maintained platform survives at the South Station, 600 metres south-east of Brookwood Station. This served deceased Anglicans, while the North Station catered for everyone else – Catholics, Nonconformists, Muslims, Hindus, Parsees and atheists. Above is the South Station in April 1970, looking towards the buffer stop. The shed for biers is on the far right, while the building in the foreground accommodated two chaplain's rooms and a gentleman's toilet. On 22 September of that year, the station was ravaged by fire; although more than half of it survived, it was demolished soon afterwards following vandalism.

The station site today lies within the monastic enclosure of the Orthodox St Edward Brotherhood (the nearby church is dedicated to that tenth century martyr, whose relics it houses). In the former mortuary chapel near the Brothers' quarters, shown below, the community has created a small museum dedicated to the cemetery railway.

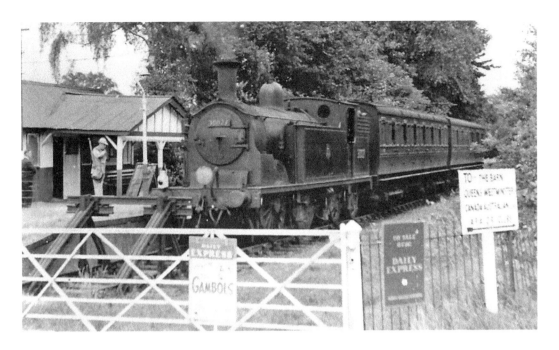

Bisley Camp Station

The short (1.25-mile long) branch from Brookwood Station to Bisley Camp, the headquarters of the National Rifle Association, opened in 1890 and closed in 1952. It was open only for about one month a year to serve the NRA's Annual July Meeting. The railway never earned much revenue but was of value during both world wars. The 1916/17 extension to the major encampments of Pirbright, Deepcut and Blackdown was lifted by the early 1920s, although during the Second World War one was laid as far as Pirbright Camp. The station building here served in recent years as the clubhouse of Lloyds TSB's Rifle Club, with the BR Mark 1 coach being used for members' accommodation. In the above picture, Class M7 0-4-4T No. 30027 arrives with the locally dubbed 'Bisley Bullet' on 12 July 1952, one week before the station's closure. The modern shot was taken on 23 September 2016.

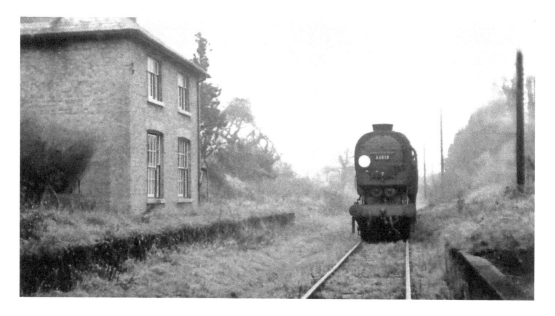

Ash Green Halt

Some seven miles away to the south-west, this halt, between Wanborough and Tongham stations on the Guildford-Farnham line, was opened by the LSWR in 1849. It was closed by the Southern Railway in 1937. Opened as Ash, it was renamed Ash Green (1876–91), Ash (1891–95), Ash Green (1895–1926) and Ash Green Halt (1926–37).

The station and its two-storey main building at the rear of the Up platform were sited in a cutting beside the White Lane road bridge, pictured below for context on 18 March 2017. The booking office and waiting room were on the lower floor while the upper floor provided accommodation for the stationmaster. The house survives as an attractive private residence, occupied by the present owners for the last ten years.

The station closed on 1 December 1926, from which date it was unstaffed and downgraded to a halt.

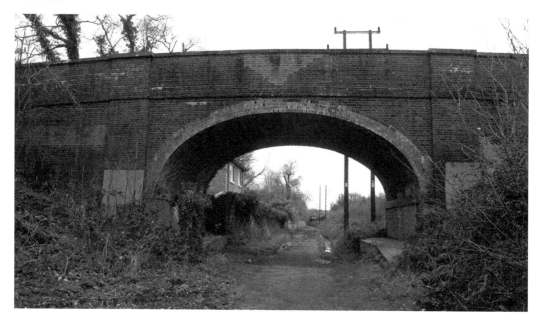

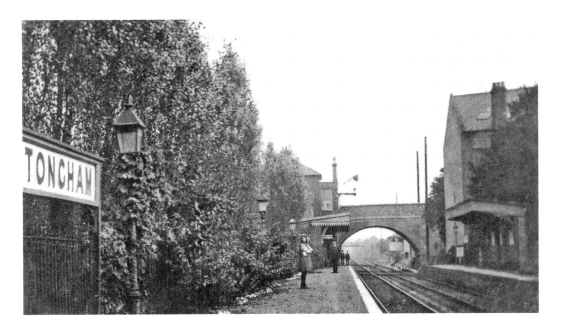

Tongham

The present-day Guildford–Alton route runs through Wanborough, Ash and Aldershot to Farnham, but the original line took a more south-westerly direction through Ash Green and adjacent Tongham. When electrification came in July 1937 both stations closed to passenger traffic and in 1961 the line was finally abandoned. No trace remains of the station – which, like Ash (Green), had a two-storey station building and a goods yard – or of the road bridge over the line, although in the view below, looking north-east in March 2017, the fenced and wooded area is part of the ramp up to the bridge that used to cross the track here. On the left is the side wall of 19 Ellison Way.

The surviving trackbed between the two stations is now the Old Railway Path, maintained by the local authority, which first undertook grant-aided environmental and access improvements to it in 2000 and 2001.

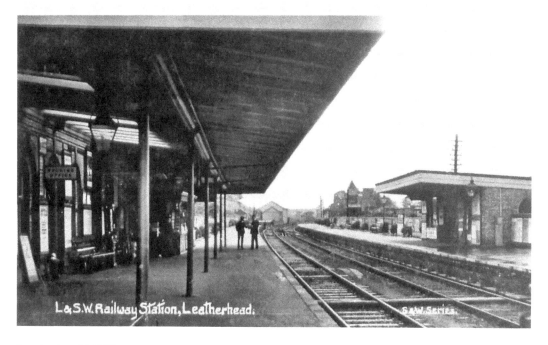

Leatherhead LSWR

The town's first station in Leatherhead was that of the Epsom & Leatherhead Railway of 1859. This was replaced in 1885 by the one shown above, built to the south by the LSWR on its line to Guildford. It stood behind the photographer, on the left, in the photo below, taken at the Station Approach/Randalls Road junction. The LBSCR had opened its own station in 1867 a few hundred yards away on its Dorking–Horsham line and that is the one which survives (*see page 63*). The lines through the two stations converged a short distance away to the north and continued towards Epsom. On 10 July 1927, the Southern Railway sensibly closed one of the stations. Subsequently, the casualty – the LSWR station – steadily deteriorated, although the tracks to it were retained for use as carriage sidings until the mid-1970s. They were finally removed in the 1980s. The reference point in both photos is the tower of the LBSCR/current station.

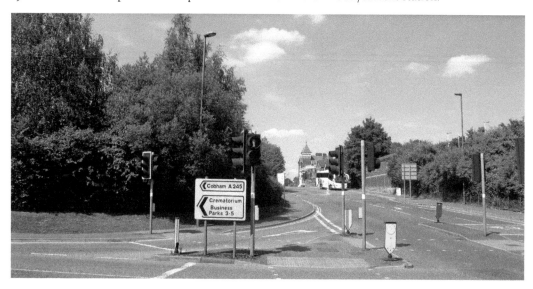

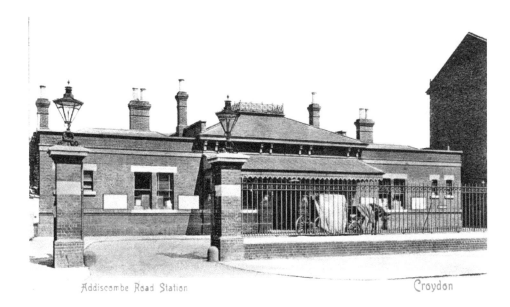

Addiscombe Road Station Croydon

Addiscombe

To the north-east, 12 miles away, once stood this terminus to the east of central Croydon. Located on Lower Addiscombe Road between Hastings Road and Grant Road, it was opened with three platforms and extensive canopies by the Mid-Kent Railway (part of the SER) in 1864 as Croydon (Addiscombe Road). Following the formation of the SECR in 1899, it was rebuilt and in 1955 renamed Addiscombe. The goods yard closed in 1968 and the station itself on 2 June 1997, when one platform remained. After closure, in preparation for the construction of Tramlink, which opened in 2000 along the former line from Elmers End to Woodside, the station lay derelict until its demolition in 2001. Today the East India Way housing development stands on the site; only sections of the walls formerly supporting the canopy and station buildings and an ornamental pillar beside Kajal's convenience store survive.

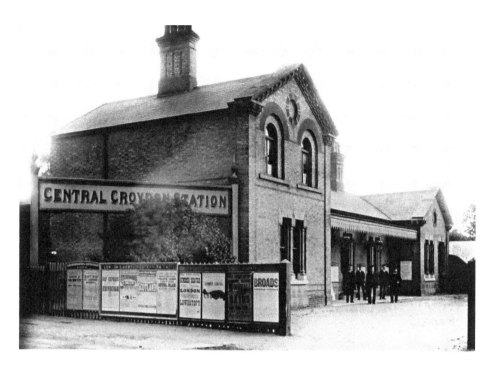

Central Croydon

This LBSCR station, located on the south side of Katharine Street and linking with New Croydon (an extension of East Croydon), only existed from 1868 to 1890, and was out of use for fifteen of those years from 1871 following poor use; nor did patronage improve under the LNWR/GER following re-opening in 1886. The station had two parallel platforms on the south side of Katherine Street and two centre roads. Its main building stood at right angles to the street and included a two-storey stationmaster's house at the north end.

Croydon Town Hall, opened in 1896, now occupies the station site, although our present-day view looks towards the Borough Courts side of the building. The cutting on the south side of Katharine Street has been retained as a sunken garden within the Queen's Gardens, which in 1983 replaced the smaller Town Hall Gardens. A plaque commemorating the station can be seen on the retaining wall.

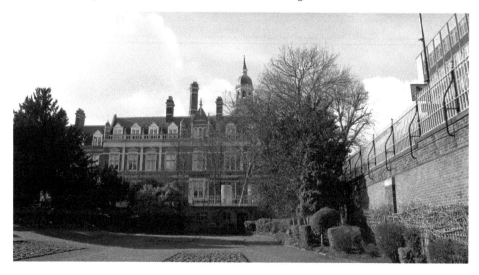

Coulsdon North

Some four miles away as the crow flies, Coulsdon North opened as 'Stoat's Nest and Cane Hill' in 1899. It was named 'Coulsdon and Smitham Downs' between 1911 and 1923 and 'Coulsdon North' for the next sixty years until closure. Serving as a through station for services from London Victoria to Brighton and as a terminus for services from Victoria via Streatham Common or Crystal Palace, it opened in the same year as the Quarry Line, which by-passed Redhill. Ten years earlier, Coulsdon's first station, Coulsdon South (then named simply 'Coulsdon') had been opened by the SER.

By the 1960s, usage had begun to decline at Coulsdon North, which finally closed in 1983 as part of the resignalling of the Brighton main line. In 2006 the A23 Coulsdon Relief Road, which runs under the bridge in the foreground below, was constructed adjacent to the west side of the site.

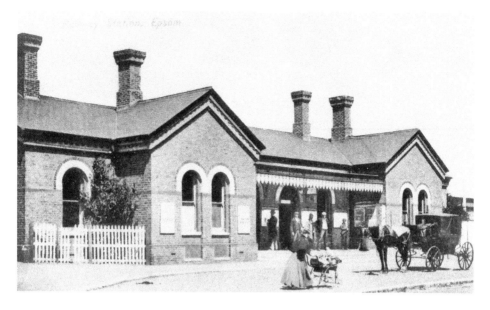

Epsom (1) (ex-LBSCR)/Epsom Town

This station is unique, certainly in Surrey, in surviving half-concealed behind a row of shops in a busy street (Nos 49–57 Upper High Street, previously Station Road). Part of the building (No. 47A) is occupied as a residence, accessed from the alley facing the bus stop.

Epsom was first reached by rail in 1847, when an LBSCR extension from West Croydon was opened with a terminus, initially named Epsom, at this location. Renamed Epsom Town in 1923 to avoid confusion with a second station not far away opened as a joint venture between the LBSCR and the LSWR in 1859, but only serving the latter (*see page 61*), it was in 1870 replaced by today's disused survivor, with staggered platforms connected by a subway. As part of its rationalisation, the Southern Railway, a combination of several pre-1923 companies, closed Epsom Town in 1929, rebuilding the tracks at the ex-LSWR station so that two island platforms provided cross-platform interchange.

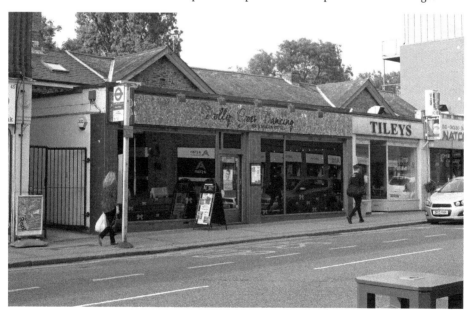

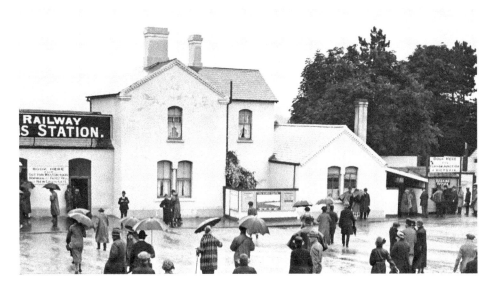

Epsom Downs

No information was provided with this interesting postcard of numerous passengers heading for the station on a rainy day in probably the early 1930s, but the sign on the left tells them they can book there for Sutton, West Croydon, Norwood Junction, Forest Hill and New Cross Gate, while the hut on the right sells tickets for Clapham Junction and Victoria.

When opened in 1865 the station had nine platform faces, most of them only used during the popular race days at nearby Epsom racecourse. Following the decline of horse racing, just one platform remains in use today.

The then station was closed in 1989 and resited some 300 yards to the north-east, where services have since 1982 operated on a single track, doubled just beyond Belmont. No trace remains of the Southern, ex-LBSCR, building depicted or associated structures. Part of the site is today occupied by 2 Bunbury Way, pictured below, and neighbouring properties.

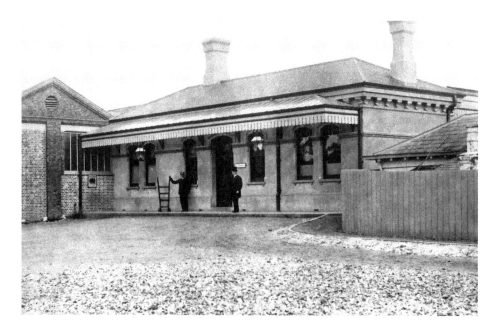

Horley (1)

In this, the first of two pages devoted to this station (*see page 72*), two 'then' views are presented, since the well-appointed 1905 station below, straddling the railway lines on Victoria Road, has changed little over the last 112 years, save for the loss of the frontage canopy. As on the previous page, the earlier (1841) LBSCR station, designed in pleasing Tudor style by David Mocatta and reconstructed in a more utilitarian fashion in 1882/83, stood some distance to the north of its replacement – in this case 301 yards. The western exterior is shown above. The original engine shed later became the goods shed and was also used for the storage of rolling stock and as a granary at different times. It abutted the long station platform on the Up side and is now a Factory Shop outlet. It stands in Consort Way East and is locally listed.

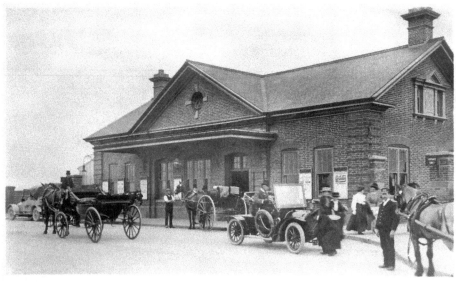

S 5368 L B & S C RAILWAY STATION HORLEY

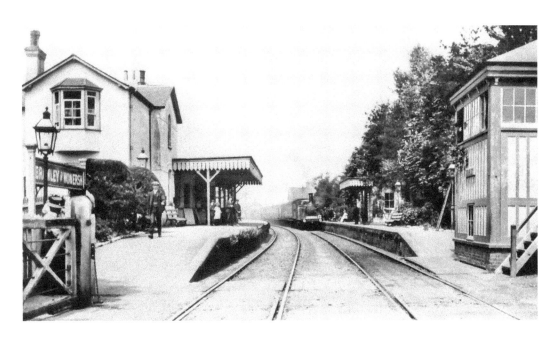

Bramley

Moving some 17.5 miles across the county as the crow flies, we now visit the partly preserved Bramley and Wonersh Station on the long-closed Cranleigh Line of 1865, linking Horsham and Guildford. Like the other two Surrey stations on this line, Bramley missed celebrating its centenary by just a few months when closure came in 1965 following the Beeching report. Demolition soon followed.

Named 'Bramley' when it opened, it was renamed 'Bramley and Wonersh' in June 1888. A passing loop and a second platform were installed in 1876. Looking at the peaceful image above showing a train headed by a Stroudley D1 0-4-2T at the platform in 1908, it is hard to imagine the chaos and carnage that ensued when a Dornier 217 aircraft attacked a train carrying Christmas shoppers as it was leaving the station on 16 December 1942. The driver and guard lost their lives, a number of passengers were also killed or wounded, and the train was badly damaged.

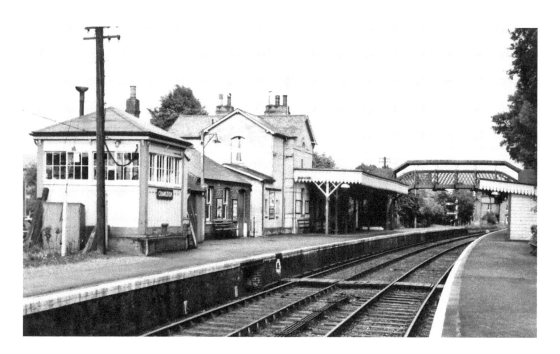

Cranleigh

Some five miles to the south-east stood Cranleigh Station, named 'Cranley' during its first two years. In 1880, a passing loop and second platform were installed, four years after those were provided at Bramley and Wonersh. Since Cranleigh was the largest village on the line, its station was also the busiest, with regular commuter traffic to and from London via Guildford and regular custom for nearby Cranleigh School. Located in the middle of the village, the station boasted a small goods yard and coal depot.

Sadly, nothing remains. The station frontage site is now a row of shops, with maisonettes above, called 'Stocklund Square'. In 2004 half of the row of shops and the existing Somerfield supermarket were replaced by a new Sainsbury's supermarket. The loading bay area behind the square was the site of the platforms and tracks. Our photos look south-east towards Horsham.

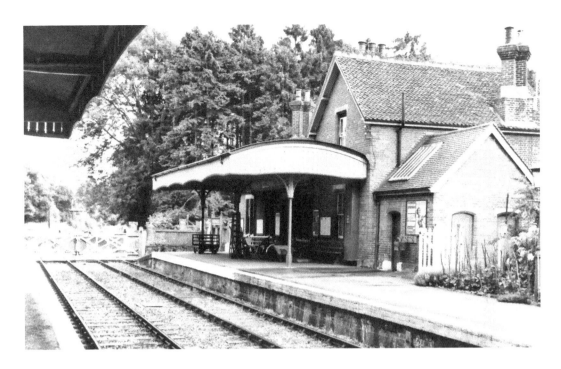

Baynards

Built for Lord Thurlow, the owner of nearby Baynards Park, this was the southernmost Surrey station on the single-track Cranleigh Line. In our early view, looking south-west in probably the early 1960s, we can see on the right some of the thousand dahlias of 240 different varieties that signalman Geoff Birdfield grew alongside both platforms. This archetypal country station was used in the early days as the local post office – and in February 1957 for the filming of *The Railway Children* for BBC TV. Although sleepy in appearance, it was important in its heyday for freight, serving a nearby operation that was ultimately a chemical processing works, which produced Fuller's earth for the wool industry and (in later years) foundry clays. The goods shed has been preserved.

The station fell derelict after closure but was purchased by private buyers in 1975. It has been lovingly and skilfully maintained ever since.

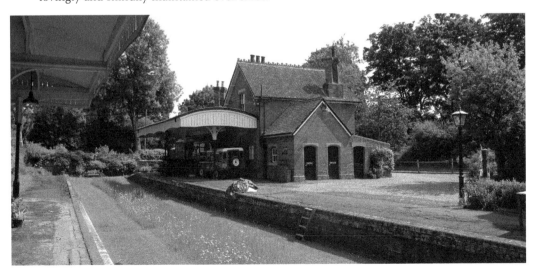

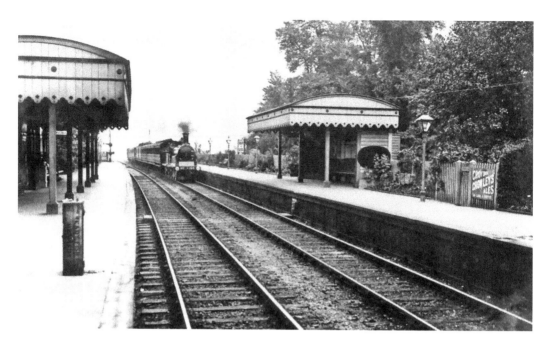

Coombe Lane

Some 40 miles north-east of the border area with Sussex stood Coombe Lane Station on the relatively short-lived and unsuccessful LBSCR/SER Woodside and South Croydon Joint Railway (W&SC), opened in 1885. So unprofitable was that venture that it made a substantial loss in every year but one up to 1900. Yet, in the 1930s public funds were spent on its refurbishment and electrification, while in May 1956 this station's platforms were lengthened for ten-coach trains. Although the line closed in 1983, its route has largely been revived by Tramlink (of which more later).

The above period piece shows a locomotive numbered 195 entering the station in the early years of the last century. The tracks went diagonally across Larcombe Close on the left (*see below*), joining the course of the Croydon Tramlink hereabouts. Tram No. 2541, southward bound for New Addington on Tramlink Route 3, is passing that junction point on 26 January 2017.

From Trains to Trams

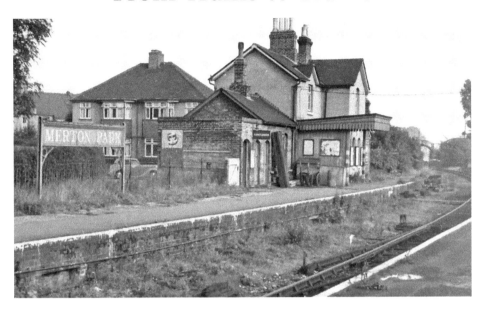

Merton Park

This station, which closed in 1997, stood on the Tooting, Merton & Wimbledon Railway (TM&WR) loop opened on 1 October 1868. The starting-point of the line, of which only the Haydons Road branch survives today, was Tooting Junction (now plain Tooting). Lower Merton – as Merton Park was initially named until changed in 1887 by the LBSCR, operating jointly with the LSWR – was a junction in its own right, serving both the Tooting line via Merton Abbey until 1929 and the Wimbledon–West Croydon Line.

Today, Tramlink's Merton Park stop is at the north-west end of the original station. Some 200 yards south of the site, the former station building (*above*), with a windbreak provided at the west end of the canopy, has now been pleasingly converted to a private residence – Old Station House. Part of its roof can be glimpsed in the photo below taken on 29 September 2016.

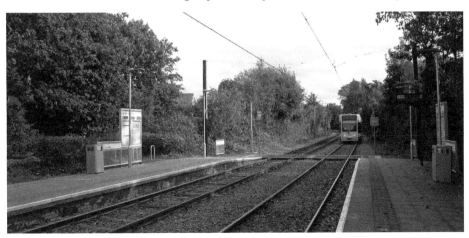

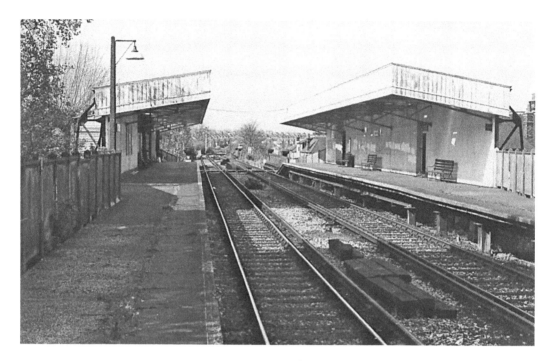

Bingham Road

Bingham Road, 6 miles away to the south-east on the Elmers End to Selsdon line, had two lifetimes: as a halt from 1906 to 1915 and as a station from 1935 to 1983. Located between Coombe Lane and Woodside, with two timber platforms made from old sleepers and no buildings, it was short-lived in the first period, closing on 15 March 1915 as an economy measure during the First World War. Not until 1935 did it reopen. With declining use over the ensuing decades and ultimately reduced to a shuttle service between Sanderstead and Elmers End, however, the line finally closed on 13 May 1983, the track being lifted during the following summer.

The station stood on an embankment 20 feet above the level of the present tram tracks, viewed below on 26 January 2017 from Lower Addis Road looking north towards Woodside. Above is the station as recorded on 6 May 1983.

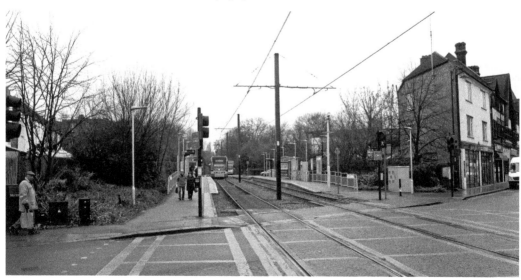

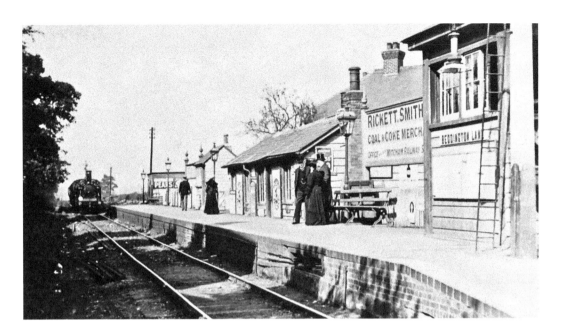

Beddington Lane

This small single-platform station on the West Croydon–Wimbledon Line was built on the site of the Surrey Iron Railway by the Wimbledon and Croydon Railway (W&CR), which opened the station as 'Beddington' on 22 October 1855. It was renamed 'Beddington Lane' in January 1887. In 1919 it became 'Beddington Lane Halt' but reverted to 'Beddington Lane' on 5 May 1969. The old station building probably dated from 1855 and was still standing, according to photographic evidence, until at least 1991.

Adjacent stations on the line, which was closed on 31 May 1997, were Mitcham Junction to the west and Waddon Marsh Halt to the east.

The charming Edwardian photo above was taken on 23 September 1906. The current view, showing Elmers End-bound tram No. 2558 at the Beddington Lane Tramlink stop, which opened in 2000, dates from 29 September 2016. The stop is located some distance west of the original station site.

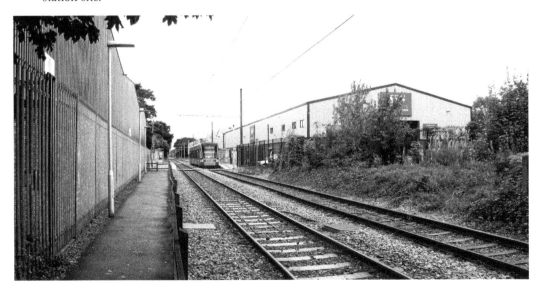

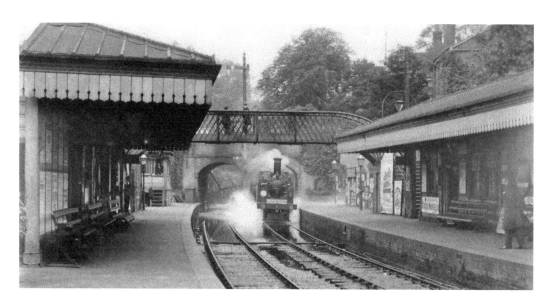

Mitcham

It has been claimed that Mitcham is the oldest continuously working station in the world, since the W&CR's predecessor was the Surrey Iron Railway, referred to on the previous page, a horse-drawn plateway which operated from 1802/03 until 1846.

The dramatic early picture above depicts a train splashing its way into the station in June 1903 en route for West Croydon. Beddington Lane will be reached after Mitcham Junction.

At top right of the photo the chimneys of the main station building of 1855 may be seen. This has survived as Station Court (Nos 409–11 London Road), which is currently used in part and owned in full by Mitcham Physio.

The present-day photo of the Tramlink stop, replacing the station closed in 1997, shows a 1980s block of six flats built close by, echoing the design of the station house behind it. Alongside both properties, the base wall of the disused platform and the old station retaining wall are visible in places.

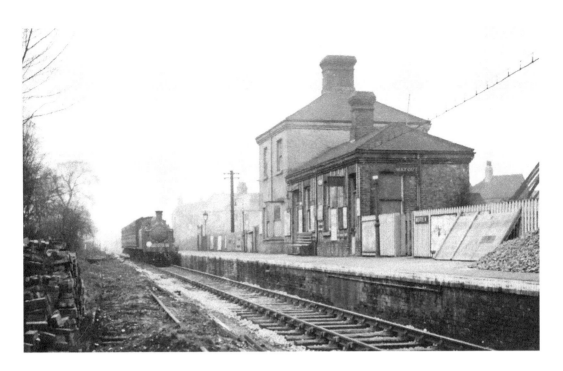

Morden Road

Next to Mitcham, towards Wimbledon, stood Morden Station, opened in a thinly populated area in 1855, although it was not until March 1857 that it first featured in a timetable. It is seen here in around 1929 looking north-west, complete with substantial buildings that lasted until November 1982. The siding seems to have just been lifted.

The station was renamed 'Morden Halt' in 1910, 'Morden Road Halt' in 1951, and 'Morden Road' in 1969. Shortly after closure of the line on 31 May 1997, the original platform was demolished and the two-platform Morden Road Tramlink stop was built on the site. Below we see Tram No. 2460 arriving en route for Elmers End on 29 September 2016.

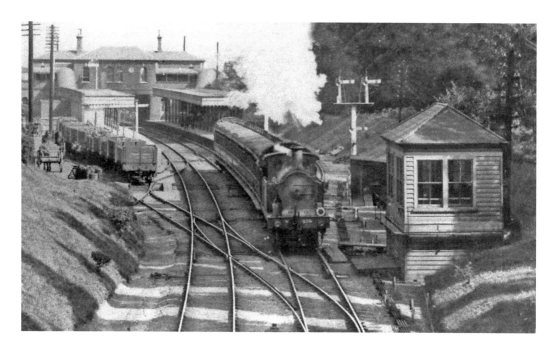

Woodside

The SER opened this station on the Woodside & South Croydon Joint Railway as 'Woodside' with three platforms in July 1871 to serve the nearby Croydon racecourse. Usage decreased after the racecourse closed in 1890, however. Renamed 'Woodside and South Norwood' in 1908, it reverted to 'Woodside' in 1944, by which date it had lost a platform.

From October 1939 the station was served by a shuttle to and from Elmers End. During the Second World War, services were drastically reduced and the line never really recovered.

The abandoned station building survives across the tracks, its windows boarded up, on the Spring Lane road bridge. The small goods yard, which closed in 1963, has for the last twenty-plus years been occupied by Woodside Timber.

Our steam days' picture depicts H Class 0-4-4T No. 279 heading for Selsdon Road, while today's view records Wimbledon-bound tram No. 2564 leaving Woodside stop on 26 January 2017.

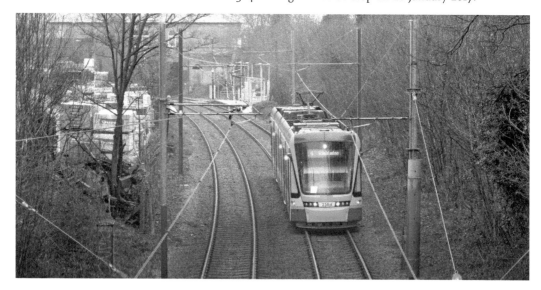

Operational Stations

Former SER/SECR Stations

The Tonbridge–Reading Line

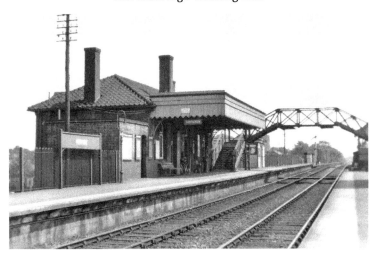

Godstone

Our journey of visits to currently operational stations formerly operated by the SER/SECR begins on the Tonbridge–Reading Line (thirteen stations) and continues with branches via Purley (six stations). We owe the 46 miles of line completed in 1849 between Reading and Redhill on the western section of the North Downs Line (connecting Reading, on the Great Western Main Line, with Redhill and Gatwick Airport, along the Brighton Main Line) to the Reading, Guildford & Reigate Railway (RGRR) Company, incorporated in 1846. In 1852 the independent company was vested in the SER.

Godstone, our easternmost station, was one of the earliest to be opened in the county (1842). It stands 2 miles or so south of the centre of the large semi-rural village of South Godstone (formerly Lagham). Until the coming of the railway, the civil parish was entirely farmland with a few scattered woodlands. The station building, now no longer, was rebuilt by the SECR in 1914/15.

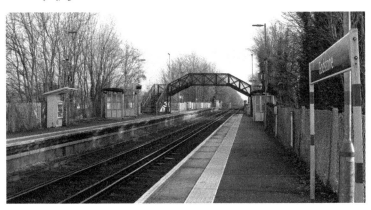

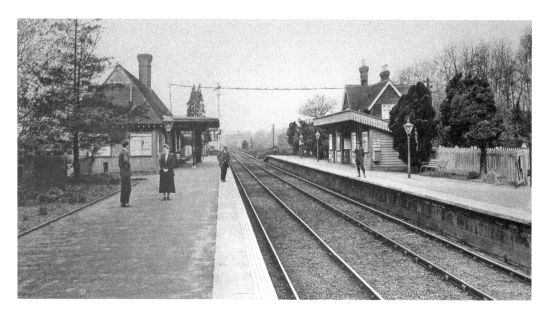

Nutfield

This attractive picture of the station is thought to date from the late 1920s, since when much has changed. The buildings were demolished in the late 1960s and the shelters have been replaced by two small bus-stop shelters. Modern housing is all around.

Nutfield opened 42 years after its eastern neighbour, Godstone, on 1 January 1884, although a public siding named 'Mid Street' had been provided here from an early date.

For many years a private siding served the chemical works of the Nutfield Manufacturing Company, located on the site of a former brickworks nearby. Goods facilities were withdrawn and coal traffic ceased in 1966. The signal box remained in use until 1970.

Until electrification in 1993 all passengers crossed the lines at rail level at the western end of the platforms, but now there is a footbridge.

Unsurprisingly, estimated annual passenger usage at this quiet station decreased from 108,000 in 2011/12 to 93,694 in 2015/16.

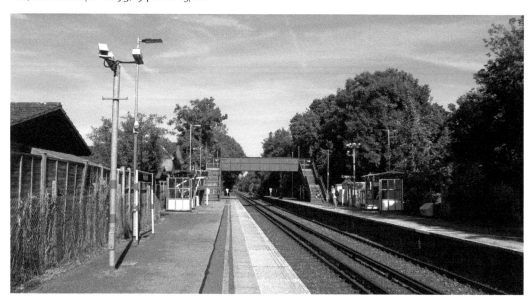

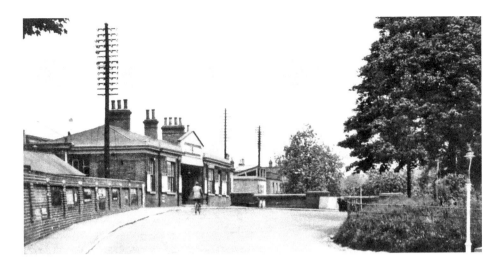

Redhill

Above we see the east side of Redhill Station, off Redstone Hill, in about 1910. Today, Station Approach is hemmed in by commercial development, although the old wall on the left has survived.

The station was opened in 1844 for joint use by the SER and the L&BR (London & Brighton Railway), which shared the route – with cooperation difficulties – from Croydon to Redhill by parliamentary decree. In 1899, the LBSCR built the 'Quarry Line' between Coulsdon North and Earlswood, which avoided Redhill altogether. Known as 'Reigate' until 1849 and 'Reigate Junction' until rebuilding in 1858, the station was then renamed 'Red Hill' (later 'Redhill Junction') and finally 'Redhill' from 1929.

Today a new Platform 0, expected to be in place by 2019, is under construction. Many other rail and commercial improvements are planned or are in progress at this major railway interchange, where annual rail passenger usage rose from 3.58 million in 2011/12 to 3.89 million in 2015/16 (+8.6 per cent).

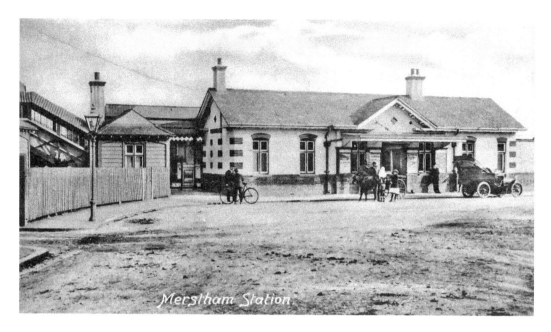

Merstham Station

Merstham

Leaving our westward journey for a while, we detour northward to visit more stations jointly operated by the SER as part of its route to Dover. Merstham Station was actually opened by the L&BR on 1 December 1841 and from 1842 was also used by the SER as the point at which travellers between the two railways exchanged trains. With the transfer to the SER of the operation of the Coulsdon–Redhill section of the line, the new owners decided to close the station on 1 October 1843, thus forcing passengers wishing to change trains to walk between the two stations at Redhill. This tactic to compel the L&BR to share the new SER Reigate station at Redhill worked; the L&BR closed their existing station at Reigate Road, Redhill, and on 4 October 1844 the SER opened a new station at Merstham on the present site. This was rebuilt, in attractive neo-Georgian style, in 1905.

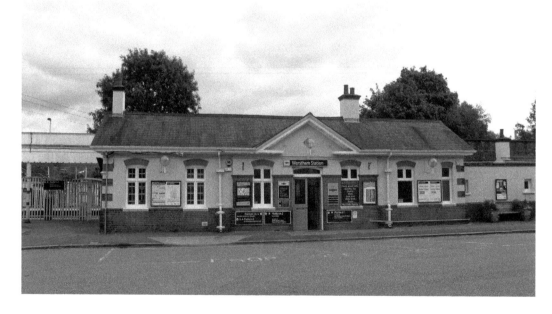

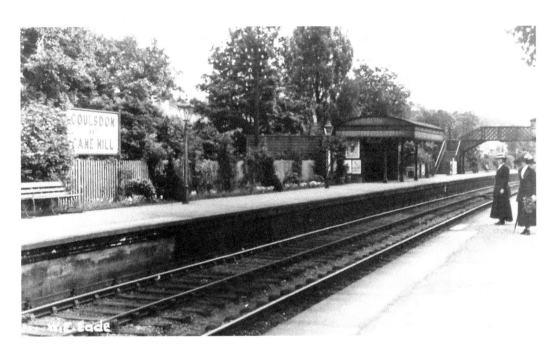

Coulsdon South

The next stop north, on the original Brighton Line, is Coulsdon South, opened as 'Coulsdon' by the SER in October 1889. The suffix '& Cane Hill' was added in 1896 with reference to the nearby psychiatric Cane Hill Hospital (the station and hospital were linked by a covered way, removed by the 1960s). The station was briefly named 'Coulsdon East' in 1923.

The goods yard was closed in 1931 due to the proximity of Coulsdon North yard and the signal box went six years later.

The canopied shelter on the Down platform has been replaced by a small glazed structure, although the Up platform – at which the 12.26 p.m. to London Victoria is arriving on 8 October 2016 – has both a glazed and canopied shelter. The latticed footbridge remains in use. Unusually, this platform has a tended flower bed and a large Lawson Cypress growing just within its bounds.

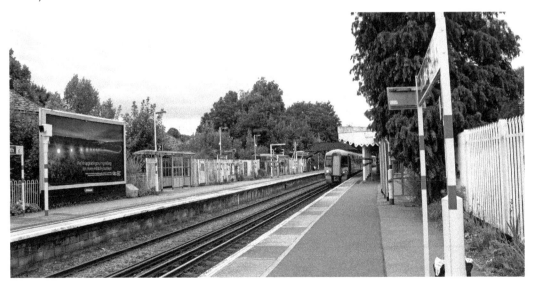

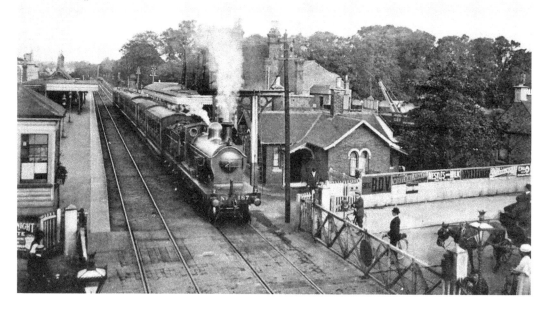

Reigate

Resuming our westward journey, we now visit Reigate Station on the North Downs Line. It opened as 'Reigate Town' in 1849 (the buildings on the north side survive from that year) when the Redhill–Reigate branch line, now electrified, was opened by the RG&RR. It was operated by the SER until 1898, in which year the SECR took over and it was renamed simply 'Reigate'. The 1929 signal box remained in use in 2016 to operate the level crossing gates. The goods yard closed in 1964 and the shed twenty years later.

The fine early view above shows SECR F1 Class 4-4-0 No. 187 at the station. The crossing keeper's cottage has now been supplanted by Foundation House, home to eleven companies.

In today's view from the public footbridge overlooking London Road on the A217, we see the back of Class 166 Network Turbo Express No. 166214 bound for Gatwick Airport at the Up platform.

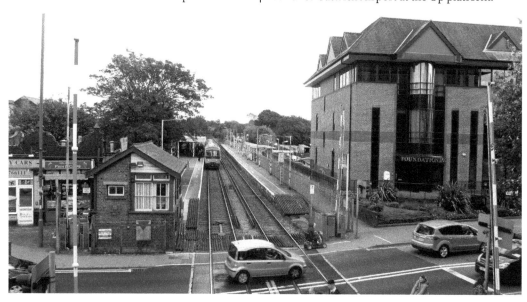

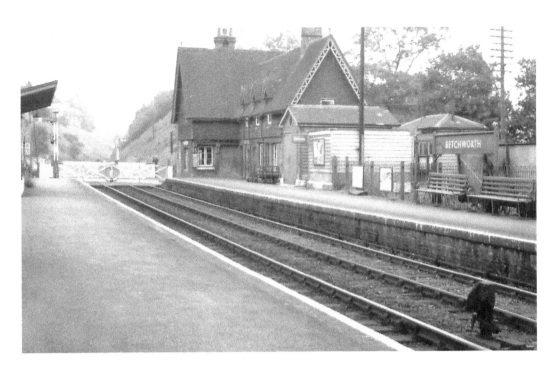

Betchworth

After Reigate, and also dating from 1849, comes Betchworth, an attractive country station with an industrial past, through its connection with quarry railways built to serve the Dorking Greystone Lime Company's three pits north of the station. No fewer than four gauges were used on the quarry line, which closed in 1959. Happily, four of the locomotives survive in preservation.

Another survivor is the original gabled-style building on the Down side. On its ground floor is an insurance business, while the first floor is in residential use.

Contrasting with our early picture of an empty station is our photographic record of 6 September 2016 showing a receding Class 166 train in blue livery – No. 166211, heading for Reigate.

Estimated passenger use has declined at this unstaffed station, from 19,878 in 2011/12 to 16,640 in 2015/16 (-16.3 per cent).

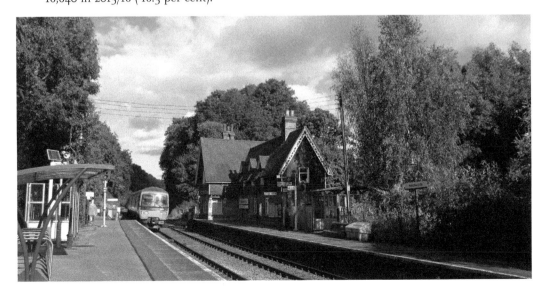

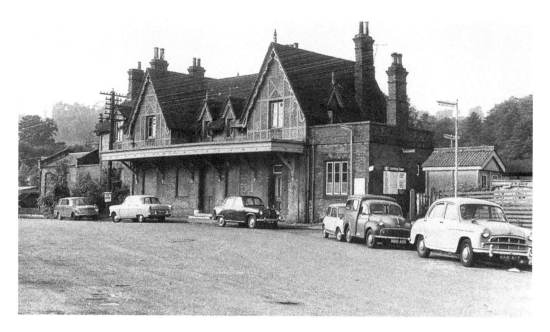

Dorking West

Next we visit Dorking West, opened with the line in 1849 in a very rural location as plain 'Dorking'. A siding was laid on the Up side in the following year for transporting materials for the building of Denbies, a large country mansion, by its owner, master builder Thomas Cubitt. A BP depot opened at the station in 1922.

The SR renamed the station 'Dorking Town' and in 1987 Network SouthEast changed the name to 'Dorking West'. Sadly, the fine station house, with its cottage orné features, was swept away in December 1969, having been unstaffed for two years.

The site and frontage area are now given over to commercial use by a car valeting service and, since 2014, by a roofing materials company, About Roofing, whose premises are within the massive former goods shed. This houses the wheel and arm of the 8-ton crane from the goods yard, which closed on 6 May 1963.

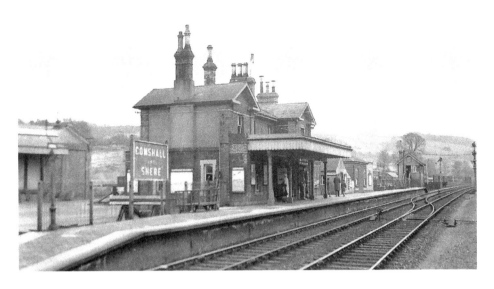

Gomshall

Above is Platform 1 of Gomshall Station (originally 'Gomshall and Shere Heath') in 1925, complete with its fine building, which was sadly demolished in 1968.

On 20 February 1904, a train carrying troops was derailed here. Although there was no loss of life, the driver, fireman and four soldiers were injured.

The prominent and unsightly brick-built signal box (*below*), now boarded up, dates from the 1940s.

The station's busy goods yard closed in 1964 and the stationmaster was transferred to Reigate three years later.

The footbridge, pictured below in June 2016 when some work was still in progress, is believed to have cost well over £2 million. Replacing the pedestrian crossing, it was officially opened on 25 November 2016 as Rosa's Bridge in honour of Rosa Sigal, a local landowner who had left Germany in the 1930s after losing her job for being Jewish. A rose motif adorns the side of the walkway.

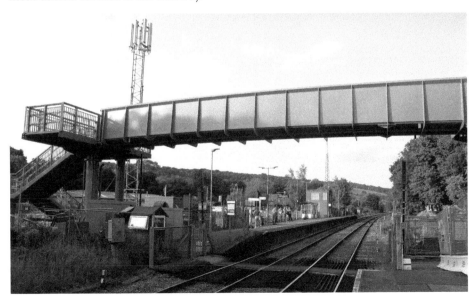

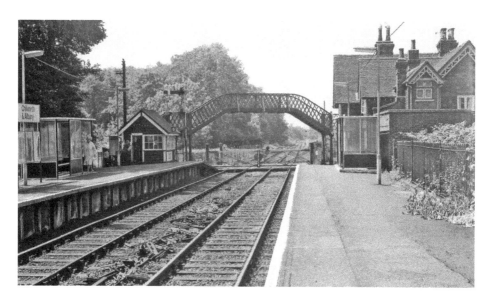

Chilworth

Until the early 1980s, this station was named 'Chilworth and Albury'. The substantial and attractively gabled station building, whose postal address is 74 Dorking Road, Chilworth, was considerably enlarged in around 1893. It survives in private use although when visited on 5 June 2016 the ground floor at least was empty and being refurbished, as far as could be seen.

Station installations have changed over the years: the barrier crossing is now CCTV-operated with the old gates now in use on the Dart Valley Railway, while the footbridge was removed to the East Somerset Railway in 1978.

Interestingly, a link to a nearby centuries-old gunpowder production site was made in 1889 via its tramway joining a new private siding just west of the station whence coal and other supplies could be conveyed to the facility. Operations ceased in 1920. Chilworth's Gunpowder Mills are today a scheduled monument.

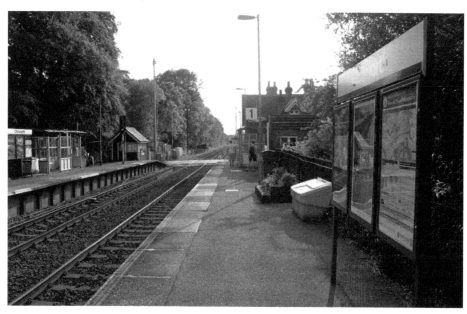

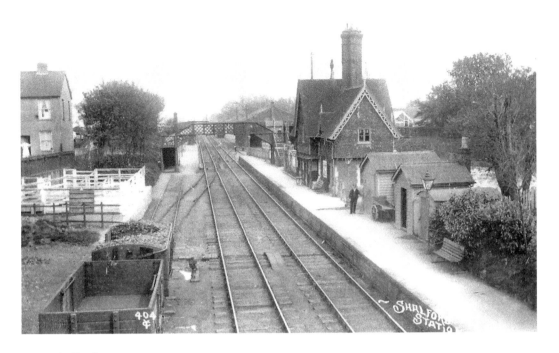

Shalford

By contrast with its easterly neighbour, Chilworth, Shalford (seen here looking east) has retained its footbridge but sadly lost its station house. The fairly ornate pillars supporting the overhang merited a photo in a volume devoted to the architecture of railway stations in the Southern Region by Nigel Wikely and John Middleton (1971). Both stations lost their wooden shelter. The now unstaffed station has suffered a 'sad decline' according to railway writer, Leslie Oppitz, in his misnamed *Lost Railways of Surrey* (2002), since it once had a complex goods yard, a narrow-gauge tramway serving a timber yard, a small locomotive shed and a large depot for making up trackwork. Had a proposed spur to the Portsmouth line been built, Shalford could, he points out, have become an important junction. As it is, the North Downs Line meets the Portsmouth Direct Line a short distance away to the north-west at Shalford Junction.

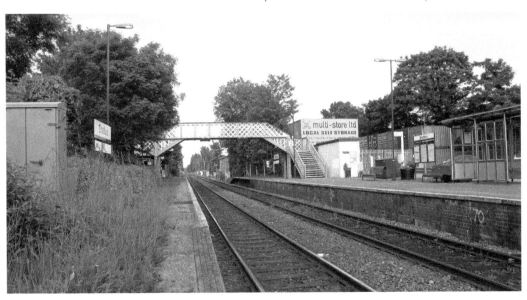

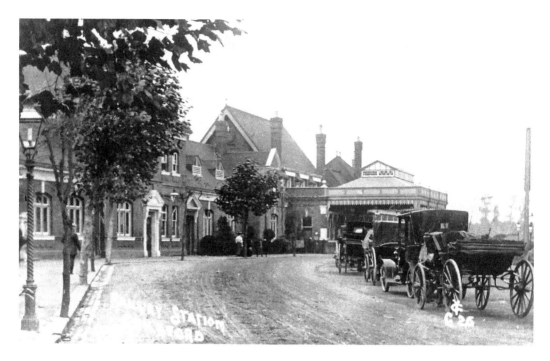

Guildford

The RGRR opened its services at what is today the busiest station in Surrey on 4 July 1849. It had been built four years earlier (on 4 July 1845) by the LSWR and should technically feature in the section of this book devoted to that railway. However, it makes sense to present it here by virtue of the RGRR's and SER's connection with it. Today the 'descendant' service operates from Platform 6 (stopping services to Redhill and Intercity services to Newcastle) and Platform 8 (services to Reading). Of the station's eight platforms, seven are in use, catering for the Portsmouth Direct Line and the New Guildford Line – the alternative route to Waterloo, via Cobham or Epsom, which calls at Guildford's other station, London Road, en route.

Once also the northern terminus of the Cranleigh Line (1865–1965), Guildford Station was substantially enlarged and rebuilt in 1880 and again in the late 1980s, as our pictures show.

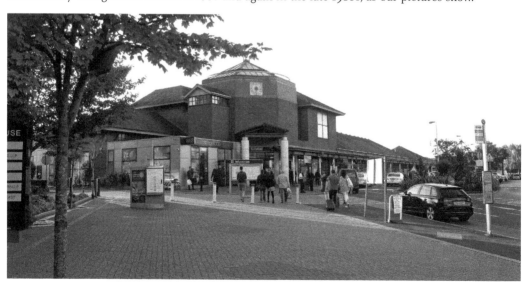

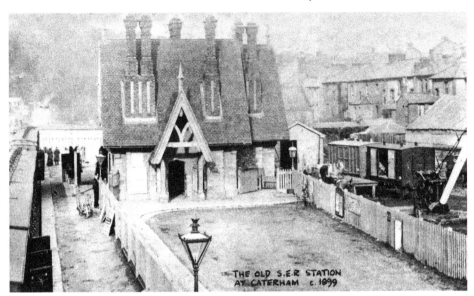

Caterham

Caterham, whose 4.5-mile Caterham Railway link to Purley was opened on 5 August 1856, is 21 miles away to the east. When the Caterham Railway Company went bankrupt three years later, the SER took it over – for half its cost. The exuberant, multi-chimneyed station building with its steeply pitched roof was designed by Richard Whittall, responsible also for Kenley's station house (*see overleaf*). It was replaced by an unremarkable successor in Station Avenue (*see below*) on 1 January 1900 on the completion of track doubling to Purley (1897–1899).

The shopping premises and car park of the adjacent Waitrose supermarket occupy the site of the original platform and station building. Next to the station's single island platform stood the goods shed of 1899, believed to have been the engine shed until 1898. This was demolished in the 1960s, together with various sidings, a coal yard, the turntable and signal box, when the land was sold and developed.

In 1961 both the signal box and goods yard closed.

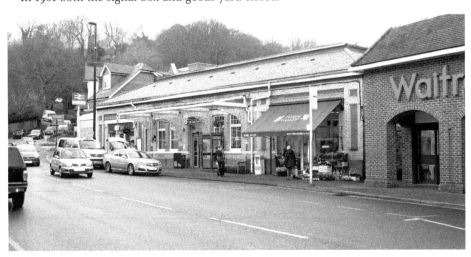

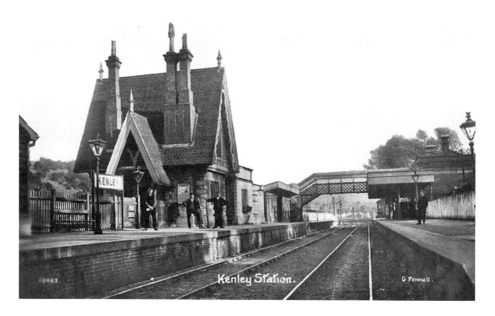
Kenley Station.

Kenley

Proceeding north without stopping at either Whyteleafe South or Whyteleafe, we arrive at Kenley. This charming station opened on 5 August 1856 as (confusingly) 'Coulsdon', but this name was quickly changed to 'Kenley', the name of a nearby country house, in December.

The original high-gabled Grade II-listed station house, another characteristic creation of Richard Whittall's, first lost its importance in 1899, when a new ticket office (*see above right*) was built at road level on Platform 1 opposite. The house, which in later years was long disused and boarded-up, was for some years prior to 2007 used as a children's nursery before being sold to Proctor Electrical Services, the current occupants, who on purchasing it needed to undertake a full internal refurbishment.

Although major work on the footbridge was carried out in 2016, the ticket office has, at the time of writing, been closed from mid-afternoon for several months.

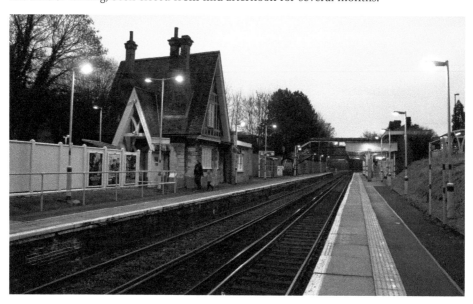

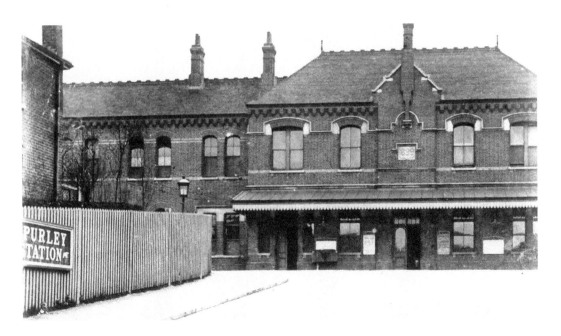

Purley

The first station here started life as 'Godstone Road' and was opened on 12 July 1841 by the London & Brighton Railway. It was closed due to low passenger traffic after only six years by the LBSCR, which had opened the new Stoat's Nest station (*see page 13*) a mile away at Coulsdon. However, its long-standing rival, the SER, whose Caterham branch was to join the main line here, legally obliged the LBSCR to allow the junction with its line and to reopen the station. This happened on 5 August 1856 when, as we saw at Caterham, the single-track branch opened.

On 1 October 1888, the station was renamed from 'Caterham Junction' to 'Purley' and rebuilt between 1896 and 1899 (see the date stone on the façade). The SER, meanwhile, built a line from Purley to Kingswood, which was extended to Tattenham Corner between 1897 and 1901. That is the branch we will look at next.

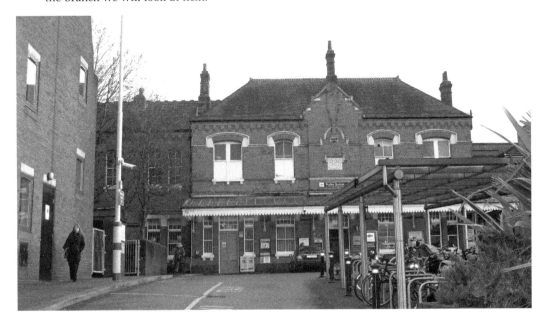

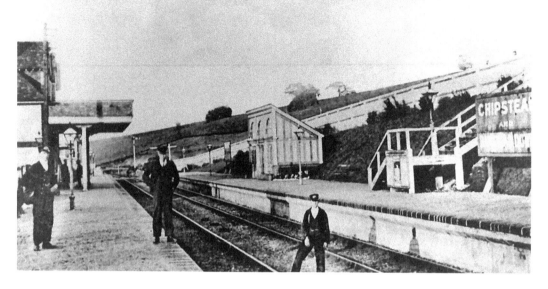

Chipstead

Without pausing at Reedham, Coulsdon Town or Woodmansterne, we arrive at Chipstead ('Chipstead and Banstead Downs' until 1923). It opened on 1 November 1897 on a then single track and was initially the only intermediate station on the branch to Kingswood and Burgh Heath – the first of two building stages of the Purley–Tattenham Corner line. The SER agreed to work the railway, absorbing the two promoting companies in 1899.

Chipstead was provided with a passing loop until track doubling in the following year.

Our period piece above, photographed from the Up, or London-bound, platform shows part of the station house with its now lost canopy and, opposite, the former steps up the embankment to today's gated Hazel Way with its five blocks of flats. The corresponding present-day image, taken on 17 February 2017, records Tattenham Corner-bound Class 455/8 No. 455822 arriving at 4.10 p.m. and more of the station house, now divided into three attractive two-bedroom town houses.

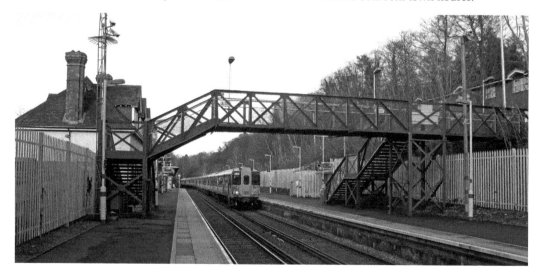

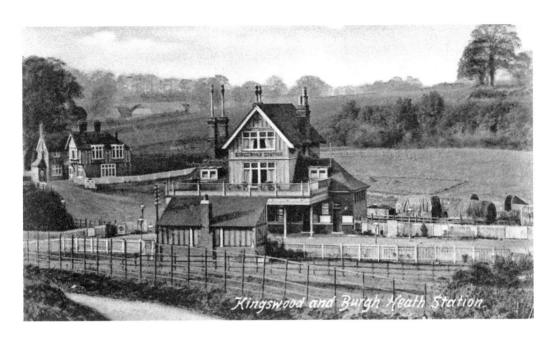

Kingswood

Due to surrounding development, our two views of Kingswood (formerly 'and Burgh Heath') Station could not be exactly matched. The nearby Station Hotel of *c.* 1900 (on the left in the above picture) became, by the mid-1960s, the Pigeon Pair public house and then, by the 1980s, the Kingswood Arms. In the nearby estate of Kingswood Warren lived, from 1885 to 1906, Henry (later Sir Henry) Cosmo Orme Bonsor (1848–1929), a brewer, businessman, Conservative MP for Wimbledon and Chairman of the SER from 1897 – the year that saw his scheme for a railway from Purley to Kingswood made a reality. Two years later he formed a private syndicate to extend the line from here to Tattenham Corner to take the racegoing traffic to Epsom Downs Racecourse. On 2 November 1997, a Bourne Society plaque in the porch of the station house (now in private commercial use) was unveiled by Bonsor's great-grandson to celebrate the centenary of the Chipstead Valley Railway.

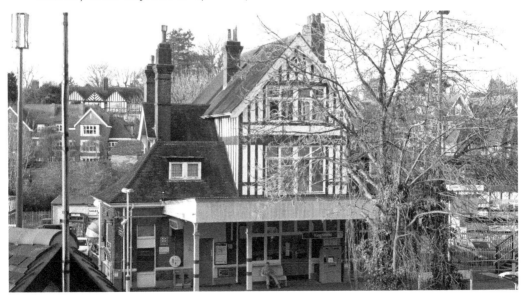

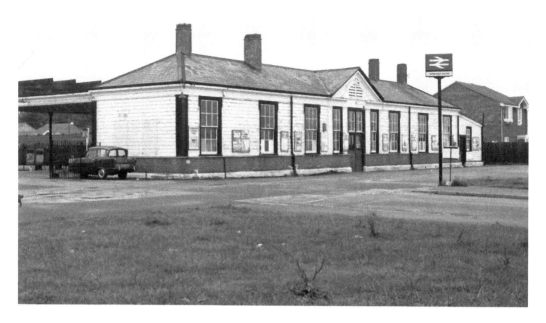

Tattenham Corner

Without stopping at Tadworth (opened as 'Tadworth & Walton-on-the Hill' on 1 July 1900), we arrive at the branch terminus, Tattenham Corner, which opened on Derby Day, 4 June 1901. Between 14,000 and 15,000 passengers were catered for here – the closest station to Epsom Downs Racecourse – on that day. Subsequent race days also generated much traffic but ordinary passenger traffic was light (seven original platforms were reduced to three as early as November 1970).

The station closed in September 1914, with trains terminating at Tadworth, although it was used occasionally for race specials from 1920 until a full public service was restored (upon electrification) on 25 March 1928. The booking office had to be demolished and replaced following an accident on 1 December 1993, when the 06.16 from London Victoria – driven by an intoxicated driver, later jailed for nine months – became embedded in the wooden building.

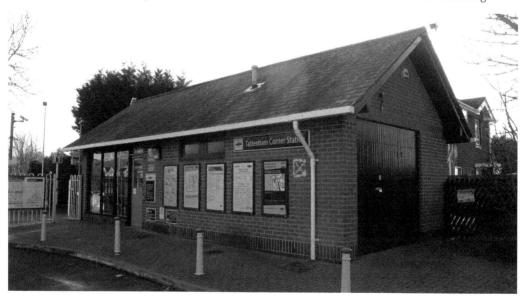

The Oxted Line

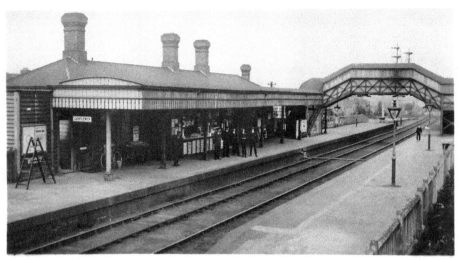

8 10031 RAILWAY STATION, SANDERSTEAD.

Sanderstead

Seven miles to the north-east of Tattenham Corner is Sanderstead on the Oxted Line, a railway originally operated jointly until Hurst Green by the SER and LBSCR via their Croydon, Oxted & East Grinstead Railway, formed on 10 March 1884. Sanderstead, 1 mile from its village, opened with the line on that date. Its weather-boarded building, pictured above with its extensive bookstall, was gutted by fire in June 1986 and replaced in September 1987 by the attractive, Continental-looking structure seen in the photograph below. The signal box was demolished in that year but the original footbridge was retained during rebuilding. This underwent a major refurbishment in 2016.

When visited on 24 September 2016, the charming station was adorned with flowers. Even a sunflower and rubber plant were on display.

Sanderstead also served as a terminus for trains from London via New Cross and Elmers End using the Woodside to Selsdon link between 1935 and 1983.

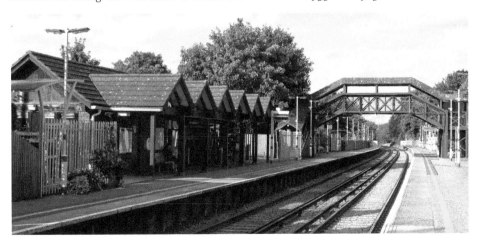

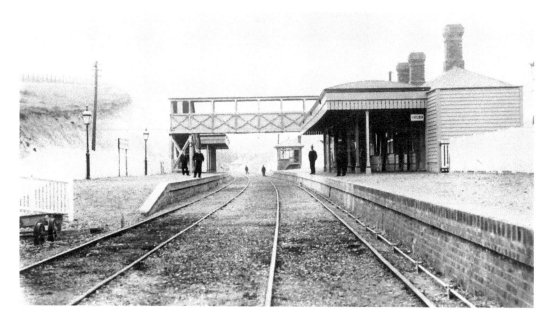

Upper Warlingham

Above is a southward view of this station taken in May 1884, a couple of months after opening. The nameboard then read simply 'Warlingham'. Ten years later, the suffix 'and Whyteleafe' was added but this was dropped in 1900, when Whyteleafe station opened on the Caterham Line some 150 yards away to the north-west. The picture shows the signal box (which closed in late 1985) at the beginning of the Up platform.

The weatherboarded station building survives but has been coated for weather protection. The station's goods yard closed in 1964.

When the station was built, the population of Warlingham was 1,100, a figure that grew to 2,500 by 1901 in response to the arrival of the railway. By 2011, the figure exceeded 8,000. The recent rise in passenger numbers has been remarkable, with annual entries and exits increasing by 50 per cent, from 0.76 million in 2011/12 to 1.14 million in 2015/16.

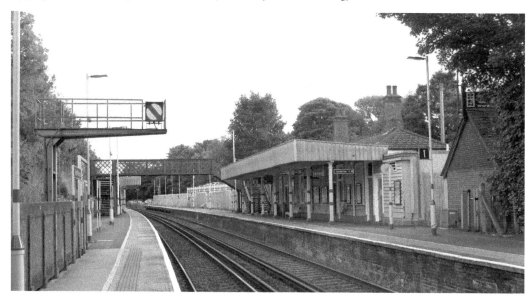

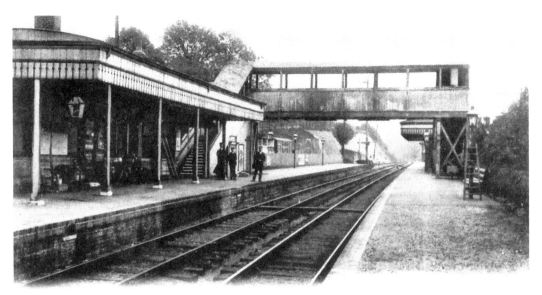

1757 – STATION, WOLDINGHAM.

Woldingham

Upper Warlingham's neighbour to the south is Woldingham, which opened in 1885, one year after the line, due to the amount of earth-moving and chalk extraction required. It was originally named 'Marden Park' after a manor south of the station and west of Woldingham village, but was renamed Woldingham in 1984.

The goods yard closed in 1959 and the signal box in 1985.

Sweeping countryside greets passengers leaving the station on the west side. Abutting the opposite platform is a brick building leased from Network Rail by the Interior Workshop, designers and suppliers of furnishings, lighting and accessories. On a small adjacent plot, yucca plants, pampas grass and a wisteria planted some years ago by the owner flourish, beautifying the station environs. The small, hedged flower border on Platform 1, colourless when seen in September 2016, is sincere but distinctly less impressive.

Services between London Bridge and Uckfield regularly pass non-stop through the station.

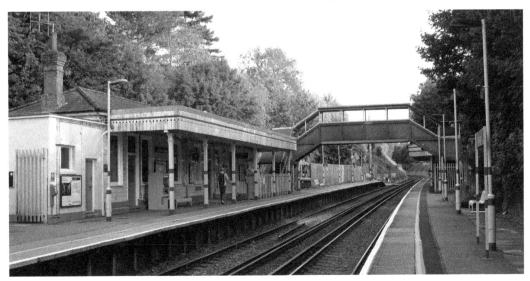

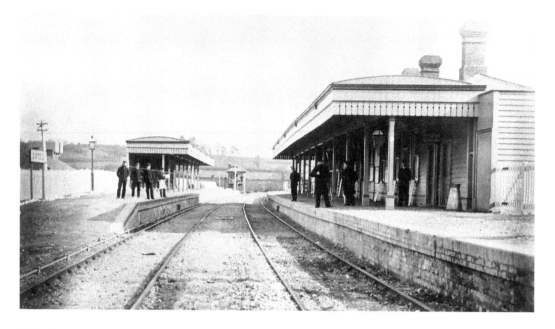

Oxted

This is the brand-new station, looking south, in 1884. It is now the busiest on the line as it additionally serves as a terminus for some services on the Uckfield branch. From its three platforms, trains also depart for London Victoria via Clapham Junction, London Bridge via East Croydon, and East Grinstead.

The sidings of the Oxted & Limpsfield Gas Company were opened east of the station in 1892. On the west side, the site of the station's extensive goods sidings and shed is today largely occupied by Morrison's supermarket and its large car park; adjacent, nearest the station, is Wetherspoon's Oxted Inn, opened in 1997. The station subway links not only all the platforms but also the town's two main streets. In 1987 a new signal box was opened and the station was rebuilt. It was refurbished in 2010 and a new lift was installed.

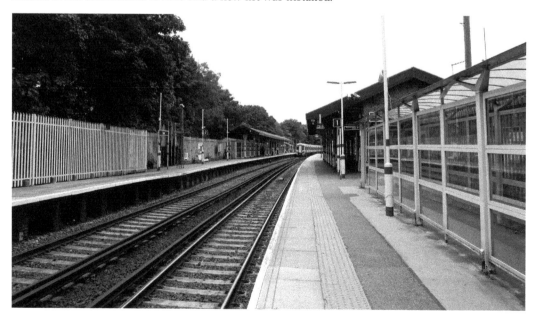

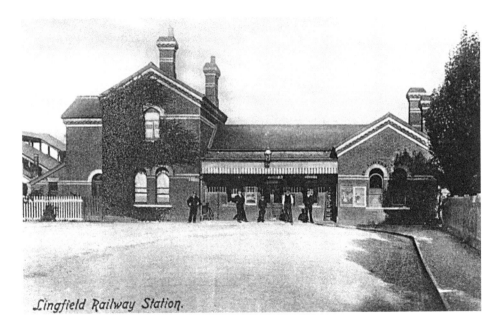

Lingfield Railway Station.

Lingfield

We are now on the LBSCR's East Grinstead fork on the Oxted Line. Lingfield village achieved fame six years after the railway arrived on account of its 140-acre racecourse at Lingfield Park, which opened in 1890. Four years later, the course was enlarged for flat racing, the Down platform became an island, and the loading dock was extended to become a departure platform for race specials. The LBSCR's 1898 authorisation to construct a line directly to the racecourse was, however, never implemented. Goods traffic peaked during the inter-war period. In the late 1950s, a large banana ripening shed was opened by Geest, which received supplies direct from Avonmouth Docks, near Bristol. It closed in 1971. In the following year, the goods shed was demolished and the Down platform canopy was removed.

Unusually, the station boasted two footbridges, one of which ended up on the Bluebell Railway. The main buildings, together with the adjoining stationmaster's house, have survived.

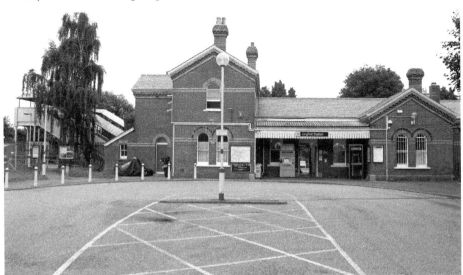

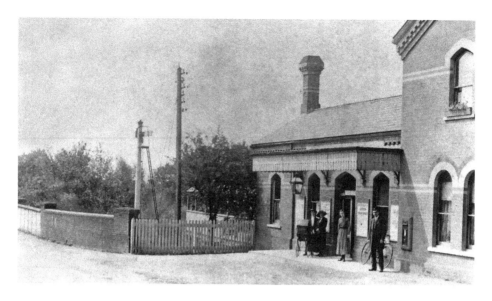

Dormans

Just 2 miles north of East Grinstead in East Sussex, Dormans station building stands in a country lane in a sparsely populated district. It serves Dormansland and Dormans Park. The former is a separate community to the east of the line bordering both Kent and Sussex, which has grown substantially since the railway's arrival in 1884 and now has a population exceeding 2,000.

Above we see the attractive three-bedroom station house in around the 1920s, rather than the Edwardian period generally assigned to it. Unusually positioned at right-angles to the track beneath the bridge, it is today a private residence.

Notwithstanding the serious damage it sustained in a fire early this century, the property has been refurbished and extended in recent years and has well-maintained gardens. The single-storey entrance and ticket office block formerly gave access to covered stairs, a roofed footbridge and canopied platforms, although the covering, roofing and canopies were all removed in later years.

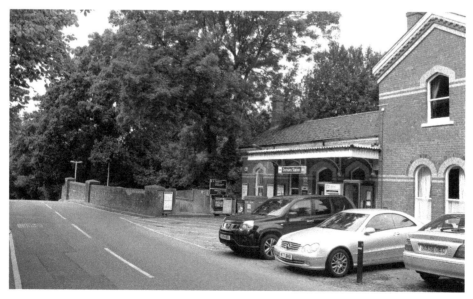

Mitcham Junction to Ockley

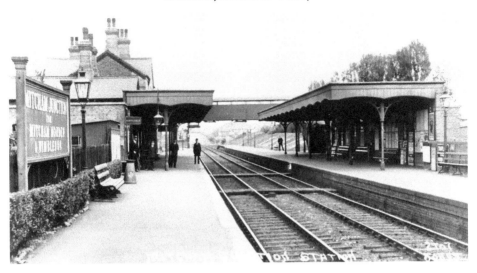

Mitcham Junction

Moving some 18 miles north-westward, we now examine twenty-two stations operated by the LBSCR. This station opened on 1 October 1868 on the West Croydon–Wimbledon Line built by the Wimbledon & Croydon Railway (W&CR) over part of the trackbed of the Surrey Iron Railway. Opening in 1855, the W&CR had linked the SW main line of the LSWR to the LBSCR. In 1856 it was leased to the latter company, which purchased it outright in 1858.

Despite its name, Mitcham Junction no longer has a junction: one of the two lines which did cross here – the former West Croydon to Wimbledon Line – has become a Tramlink route, which opened in 2000. The other is used by services between Sutton and London Victoria, or London Blackfriars and beyond.

Passenger usage of Mitcham Junction increased by 43 per cent between 2011/12 and 2015/16 – from 0.387 million to 0.553 million, doubtless thanks to the adjacent Tramlink stop.

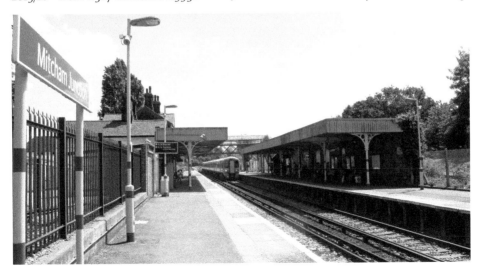

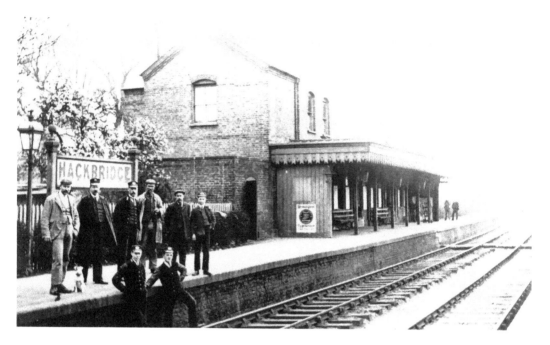

Hackbridge

Our next stop heading towards Sutton is Hackbridge, seen here with views looking north back to Mitcham Junction. Behind the photographer, steps once led from both platforms up to the London Road bridge but were removed, as was a brick-built, canopied structure on the Down platform. Beyond the natural vegetation bordering this may be seen a reservoir, whose muddy banks attract a variety of bird life. A footbridge links the two platforms.

The station building, looking almost derelict in a 1947 picture, was remodelled in 1988 but much of the original was retained, extended, and let as offices. Today, Sutton Dental Care occupies part of the ground floor, while the empty remainder and first floor are expected to be let soon. The inevitable car park covers the former extensive goods yard. Across the adjacent London Road, on the former Felnex industrial estate, a massive development of 700–800 homes plus many amenities is in progress.

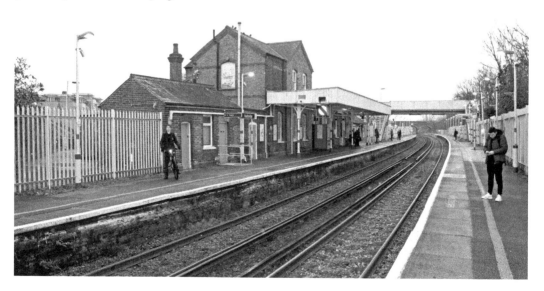

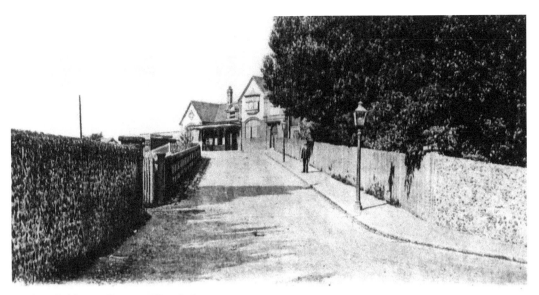

The Railway Station, Carshalton.

Carshalton

We next come to Carshalton, whose original station of that name was built on the Sutton–West Croydon line in May 1847 one mile to the south-east and is now known as Wallington. There was no station in Carshalton at first because of objections from the Carshalton Park Estate. When the station was opened with the line in 1868 it was inconveniently located some 200 yards further north in the fields south of Wallington. It moved to its present location (where there was no goods facility) in 1902, an event commemorated above the distant dormer, visible in both pictures, by an ornate carved inscription in yellow lettering on a blue background that reads 'LB&SCR 1902'.

The suburban development of the local community began in earnest in the early 1890s when the Carshalton Park Estate was sold for development.

Today, no fewer than eight businesses operate from Carshalton's attractive Station House.

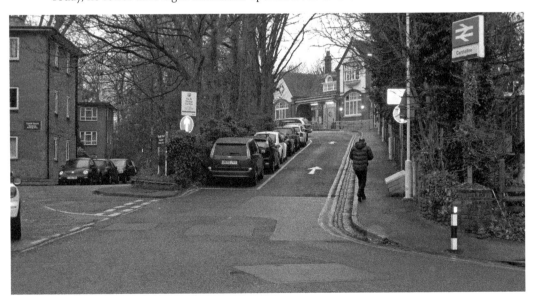

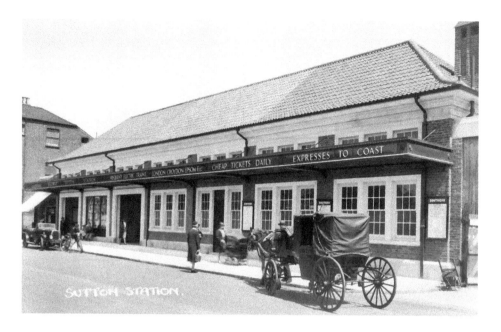

Sutton

A mile to the south-west we arrive at an important junction. Sutton Station was opened by the LBSCR in 1847 on the new line from West Croydon to Epsom. A branch to Epsom Downs was opened in 1865, followed in 1868 by the line to Mitcham Junction that we have been following. A final and late change came when the branch to Wimbledon opened in 1930.

The station building has undergone several rebuilds: the third, above the mainline tracks, took place in 1882, although its predecessor was retained for several decades, probably for use as staff accommodation. The smart and simple structure above dates from 1928. Next door (*see below*) is 'The Old Bank' public house, saved from closure in 2013. It had previously been a branch of the Midland Bank since the 1920s and, before that, Bowling's the ironmongers. Adjacent to the north side of the station, Sutton Point, a large-scale mixed-use development, is under construction.

We now make a 1-mile detour north-westward to another Sutton station.

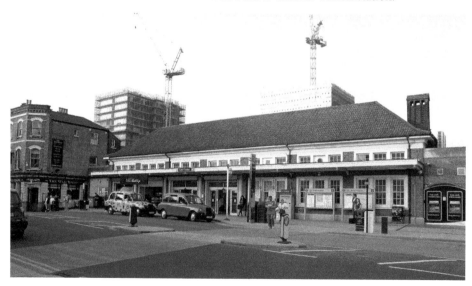

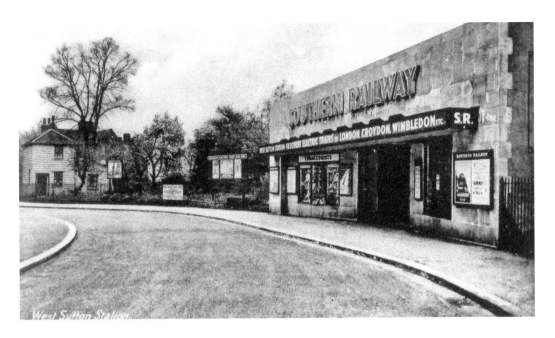

West Sutton

Despite being the youngest station in the book, having opened on 5 January 1930, this typically box-like Southern Region structure on Gander Green Lane was demolished in 1990. For its construction, a number of local residences had, ironically, been sacrificed.

Although planned as long ago previously as 1910, the Wimbledon–Sutton line via South Merton was one of the last to be built in the London area. The line to South Merton opened on 7 July 1929 and that to Sutton on 5 January 1930. With sharp curves and severe gradients most of the way, the railway was electrified from the outset and built to serve new housing estates. Only Morden South had goods facilities, with a rail link to a milk depot with at least one train of tankers per day, but this traffic has long since ceased.

Turning eastward via Sutton, we now visit Wallington en route to West Croydon.

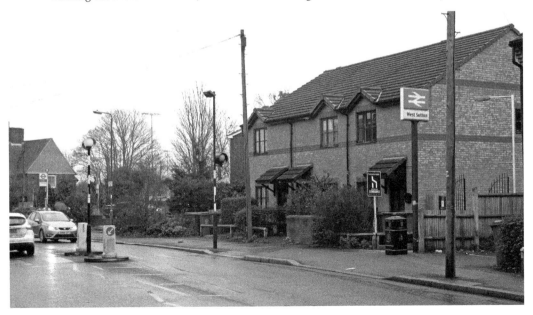

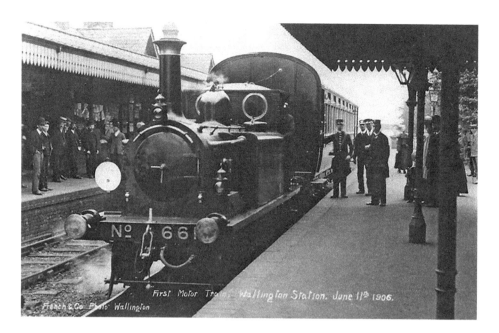

First Motor Train Wallington Station. June 11th 1906.

French & Co Photo Wallington

Wallington

Without stopping at either Sutton or Carshalton Beeches, we reach Wallington, which, like those two stations, was opened by the LBSCR on the new Croydon–Epsom railway on 10 May 1847. Its initial name of 'Carshalton' (*see page 53*) was changed to Wallington in 1868.

Our splendid period piece above records a 'Terrier' tank heading the first West Croydon–Belmont motor train on 11 June 1906. The equivalent view today shows Southern's Electrostar Class 377/6 No. 377617 arriving at Platform 2 on the Epsom Downs service at 15.19 on 26 January 2017.

The trackside goods shed and signal box were lost in 1963 and 1972 respectively.

Extensively rebuilt in about 1932, the station was completely redeveloped in 1983 at a cost of £2.75 million. It was formally reopened on 13 September of that year and now shares accommodation in Leo House with three other businesses, one of which is the Crimestoppers Trust. Some renovations were carried out in 2009.

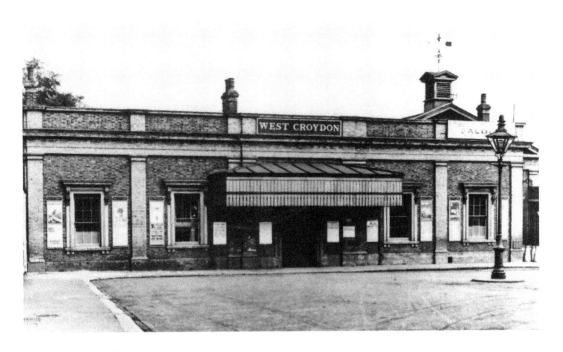

West Croydon

This was opened as 'Croydon' by the London & Croydon Railway as early as 1839 on a site which from 1809 to 1836 had been the terminal basin of the Croydon Canal. The name was changed to 'West Croydon' in 1851. When the Wimbledon–Croydon line opened, a bay was let into the south side of the Up platform to accommodate the trains. When that line closed in 1997, the rails in the bay were lifted and the platform edge was fenced. The early picture shows the ample forecourt and ticket office, behind which was the carriage shed, set back from the London Road. The station entrance was relocated to that road (*see below*) in association with the electrification extension of 1928, although in April 2012 the former side entrance in Station Road, its original offices still intact, was reinstated, allowing direct access to the station from the adjacent bus and tram stops.

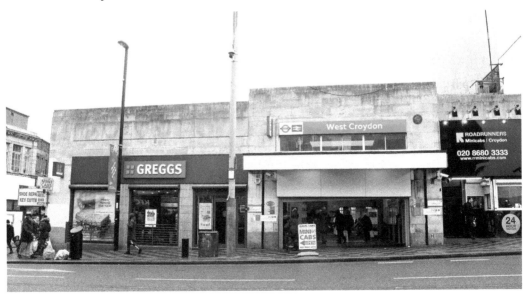

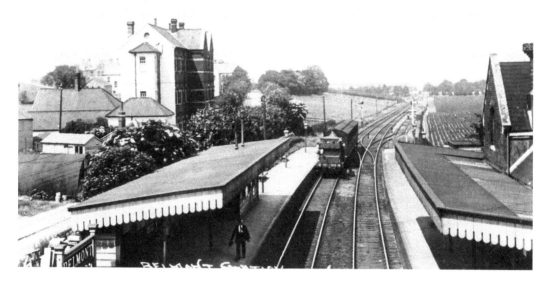

Belmont

From West Croydon we can reach the Epsom Downs Branch, originally laid as double track because of race traffic but singled in 1982. It was electrified in 1928. All trains now use the former Down platform. The Up has survived but is mostly overgrown and partly defaced.

Opened in 1865, the station was initially named 'California' after a local resident struck it rich in the American gold rush and built a public house, the 'California Arms' (today, 'The California') on his return. The station name was changed to 'Belmont' in 1875. Bomb damage was sustained in 1940.

Our early view, looking north, shows a rail motor worked by Class D1 0-4-2T No. 259 at the Up platform. The tall building on the left was originally associated with the nearby South Metropolitan District Schools. Demolished several decades ago, it latterly provided accommodation for nurses working at Belmont Hospital, the schools' ultimate incarnation.

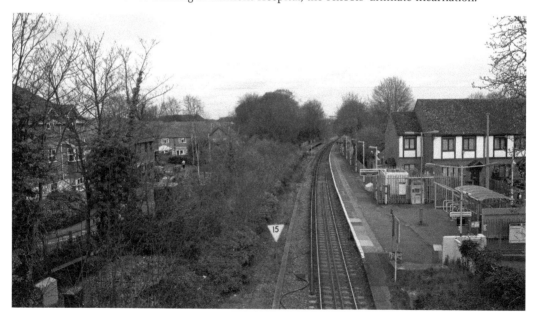

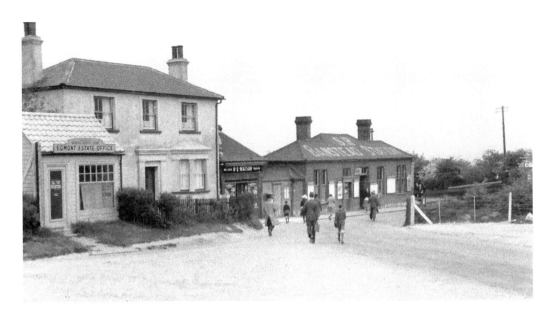

Banstead

The next station south is Banstead ('Banstead & Burgh Heath' from 1898–1928). Located on a sharp bend, the building straddles a long and deep cutting. The above view, dating from June 1936, shows the station name writ large on the roof for the benefit of passing aviators searching for Croydon airport. On either side of the stationmaster's house (today the premises of Regal Cars) stood the Egmont Estate Office (building now lost) and Watson's diminutive tobacconist's, where Britannia Builders (Banstead) Ltd currently operates.

A covered stairway leads down to the platform. As at Belmont, the trains now use only the Down platform, where there is a shelter, although the Up platform still exists.

Epsom Downs, the next station south and terminus of the branch, was described on Page 15, so we now turn to the Sutton–Horsham line to look at the stations from Cheam to Ockley inclusive.

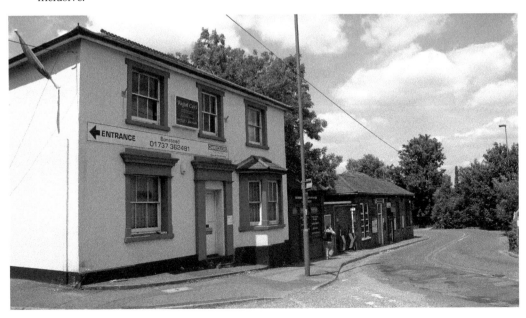

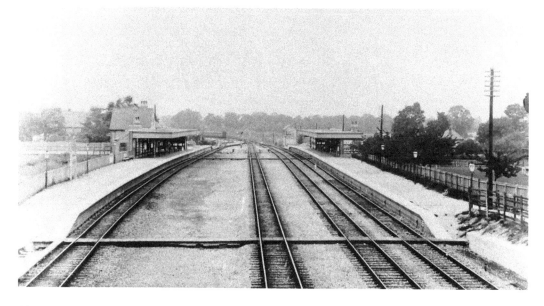

Cheam

Our first view, southward from the road bridge today carrying Belmont Rise on the A217, shows the station and tracks after the former was rebuilt in 1907 (the building was subsequently replaced by the present single-storey structure). The width of the gap between the tracks is a reminder that a central island platform was to have been built at this location to serve the planned, but never realised, AC overhead electric services. Another, earlier, scheme which remained unfulfilled was the operation of services here, and on the rest of the West Croydon–Epsom branch, using atmospheric traction. By March 1847, the year the station was built, the LBSCR had abandoned the short-lived and problem-ridden experiment.

In the photo below, a Victoria-bound service approaches Platform 1 at 19.12 on 27 May 2016. Passenger use has risen by just over 70 per cent since 2004/05, from 0.661 million in that year to 1.126 million in 2015/16.

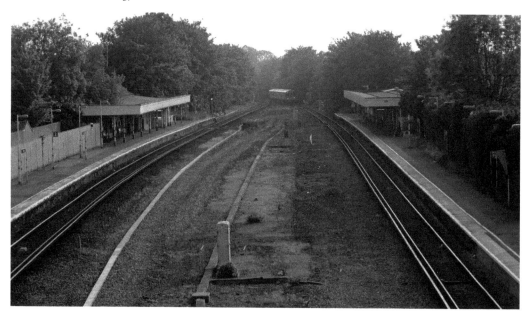

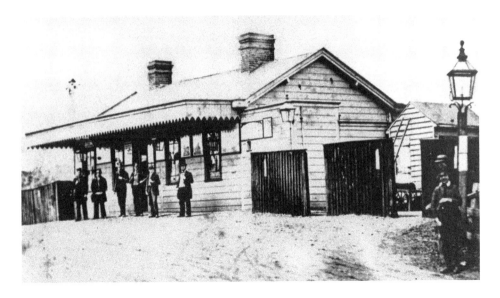

Epsom

Our early picture shows Epsom's second station around 1880. The Epsom & Leatherhead Railway (part of the LSWR) had on 4 April 1859 opened a single-track line between the two towns that was operated jointly by the LSWR and LBSCR as from February and August respectively of that year. The LBSCR station, superfluous after the Grouping, was closed in 1929 (*see page 14*) and in that year the SR demolished the ex-LSWR station off Waterloo Road, replacing it by a new joint facility.

That single-storey, rather uninteresting station building was in turn demolished in 2010 and supplanted by a stunning redevelopment opened in July 2013 that comprised a new, larger ticket office, three new shops, fifty-four affordable housing units, sixty-three apartments and a new sixty-four-bedroom Travelodge hotel, plus refurbished platform buildings, canopies, an underpass and stairs.

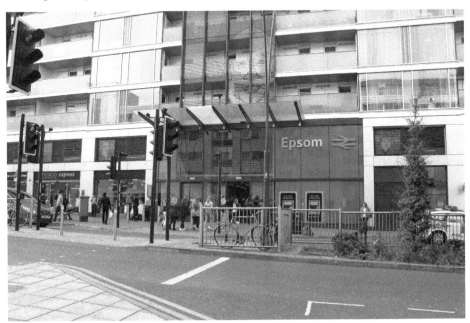

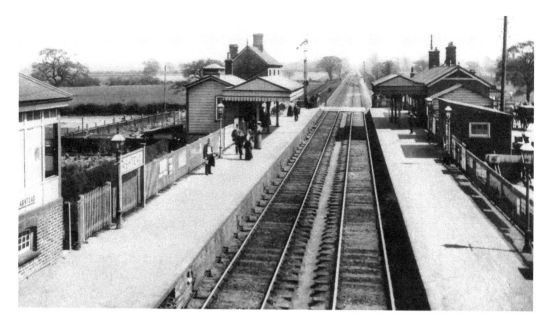

Ashstead

This intermediate station on the Epsom–Leatherhead line, doubled in 1866–67, has seen many changes over time. Gone are the station house, the second footbridge, the signal box on the Up platform (*see extreme left hand side of above picture*) and the brick building on the Down side erected by the LSWR in 1885 which accommodated a booking office, entrance hall, waiting room and staff room. On that platform, a small wooden canopied structure sheltering a waiting room and men's toilets (and later a WHS bookstall for the commuters) has also vanished. The adjacent freight yard, enlarged in 1903 in response to a first wave of new residential construction and where an estate agent's office and coal merchant's business set up shop, has morphed into a busy commuter car park.

Construction of Ashstead's new station building – now in operation – began in November 2012 as part of a £2 million station upgrade project.

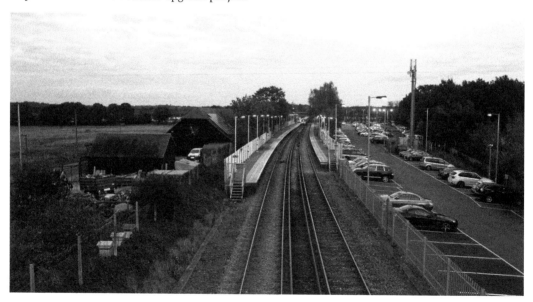

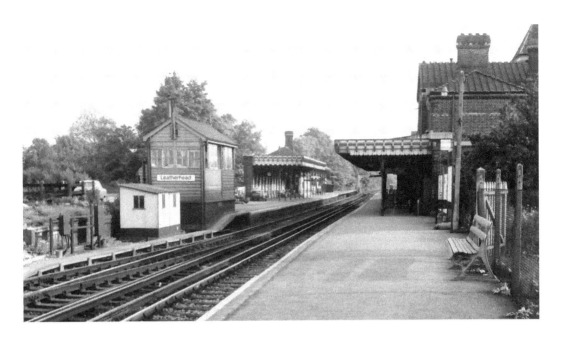

Leatherhead (ex-LBSCR)

Some distance south of the temporary joint LBSCR/LSWR station in use from 1859 to 1867, the two companies built their own stations about half a mile apart for onward travel to Dorking and Horsham (LBSCR) and Guildford (LSWR). See Page 10 regarding the closed LSWR station.

On the right in these views of the LBSCR station, which opened on 4 March 1867, is the square tower of the Grade II-listed stationmaster's house, an integral part of the main building. Its architect, Charles Henry Driver (1832–1900) also designed the now disused matching brick building, with its many arched windows and brickwork, alongside Platform 2 opposite, plus many other railway structures (*see Box Hill & Westhumble, Page 65*).

Work on a newly-improved ticket office and toilets, booking hall, a new retail unit and the waiting room finished in April 2017. Passenger use at this station rose 53 per cent between 2005/06 and 2015/16 (from 1.414m to 2.171m).

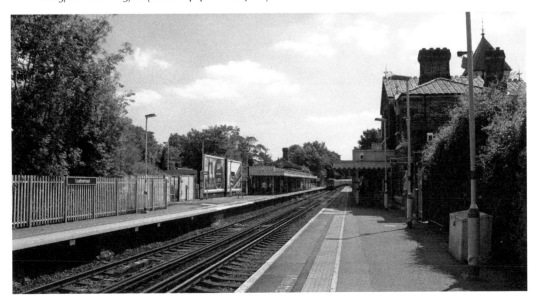

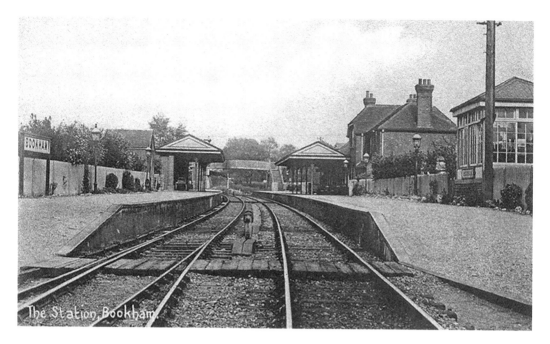

Bookham

We divert briefly south-westward for a couple of miles within this section devoted to LBSCR and LBSCR/LSWR joint stations to visit a pure LSWR station. Bookham was opened on 2 February 1885 – an important date in Surrey's late Victorian railway history, for it saw both the opening of the four stations between here and Guildford and that of the railway between the latter station and Hampton Court Junction, just south of Surbiton. Dubbed the New Guildford Line, it likewise operates four intermediate stations (north of Effingham Junction).

Built on the fringe of Bookham Common and half a mile north of Little and Great Bookham, the attractive station pictured here once boasted a goods shed and yard (closed in 1965) on the left and a signal box (closed in 1969), which can be seen above. The four-bedroom detached station house was, fittingly, bought by a railwayman in 1976 and acquired by The Station House Counselling and Psychotherapy in 2006.

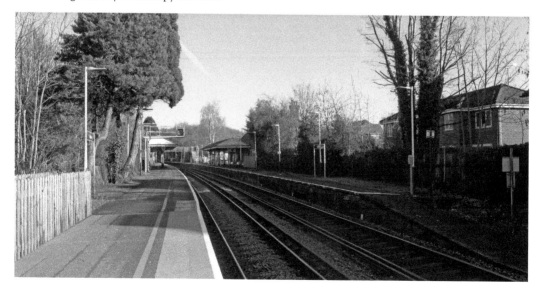

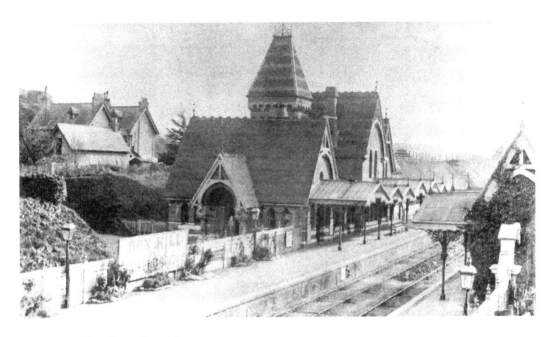

Box Hill and Westhumble

We are back on LBSCR metals, en route for Ockley.

The station sign 'Box Hill for Burford Bridge' dates the early image of this delightful station to 1870–1896 or post-1904. When first built in 1867, it was designated 'West Humble for Box Hill'. In 2006 the name was finally changed to today's 'Box Hill and Westhumble'.

The architect of the distinctive Châteauesque-style main building was Charles Henry Driver, whose railway designs included Leatherhead Station (*see page 63*), the London Bridge terminus, bridges and stations for the Midland Railway plus designs for the Three Bridges–Tunbridge Wells Central Line stations.

The former booking hall/ladies' waiting room, with gabled entrance, has for the past four years been the premises of Pilgrim Cycles, while the adjoining stationmaster's house (turreted) and its neighbour have been occupied by the present residents for eleven and twenty-three years respectively.

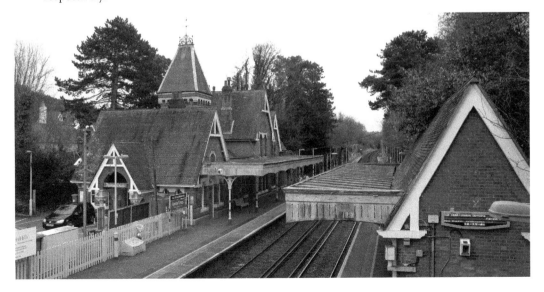

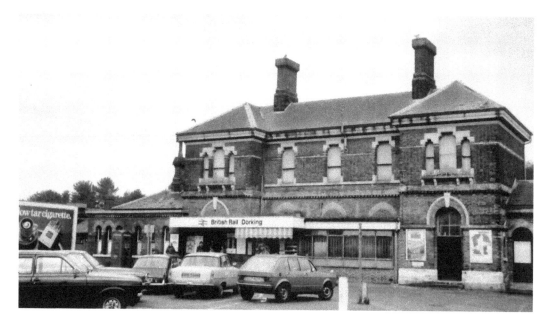

Dorking

Located 300 yards north of the SER's Box Hill (now Dorking Deepdene) Station, this is the second Dorking station to feature in this volume (*see page 34 for Dorking West*). Opened by the LBSCR as 'Dorking' on 11 March 1867, it remained so named until 9 July 1923 when it was renamed 'Dorking North'. 'Dorking' was reinstated from 11 May 1987.

Dorking was central to the scheme promoted by the independent Horsham, Dorking & Leatherhead Railway, which from 1865 built part of the Horsham–Dorking line but could not fund the rest. It fortunately amalgamated with the LBSCR, which took over the work and itself built the Dorking–Leatherhead section.

The station was rebuilt in 1983 as part of the substantial office block serving as the headquarters of Biwater International Limited – a large-scale water and wastewater company founded in 1968. Biwater also built the car park, once the site of the goods shed and a small engine shed.

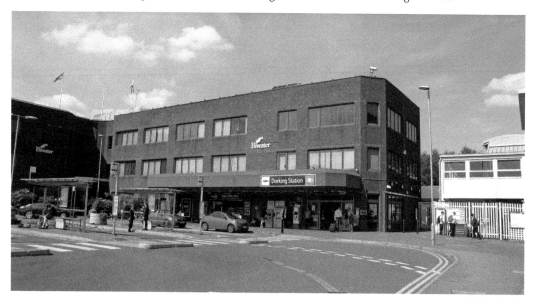

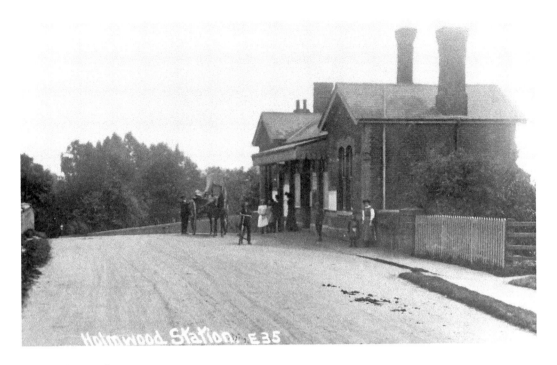

Holmwood

Four miles south of Dorking is Holmwood Station, which opened on the new line to Horsham on 1 May 1867, less than two months after Dorking. The station building, demolished during the first two weeks of April 1986, stood on the Horsham Road. Behind it was once a footbridge, originally covered. The stationmaster's house, obscured from view in the early picture but fully visible in today's photograph, survived at least and is in excellent residential condition. Another surviving structure is the small Grade II-listed signal box on the Up platform, complete with its levers, a cooker, chair and filing cabinet – all, of course, in very poor condition.

Holmwood had quite an extensive goods yard, often frequented by gunpowder vans bringing materials for the nearby Schermuly Pistol Rocket Works where the 'Verey Light' signal flares were made. The yard closed in 1964, six years after the goods shed had been demolished due to being unsafe.

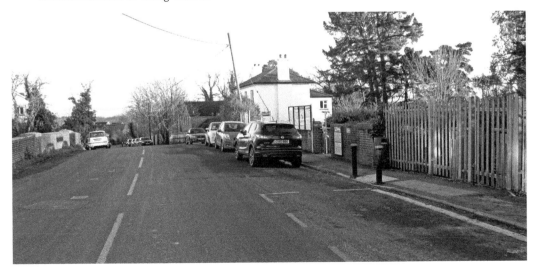

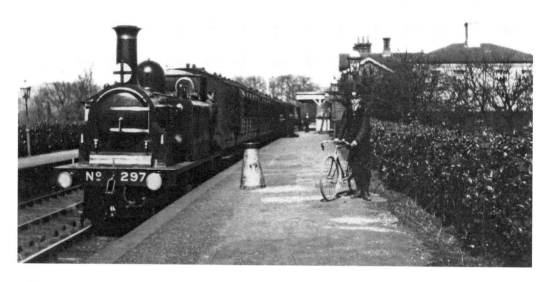

Ockley

At this next stop south – the last we are visiting on this line – LBSCR D1 tank No. 297 stands at Platform 2 in 1922, while Junior Porter Sid Dawes poses for the camera with his bike. The canopy in the background has survived largely intact. On the opposite platform, the somewhat spartan waiting shelter in the photo below adjoins the subway entrance.

The station buildings and cottages are in residential use as two dwellings respectively: the Coach House (once the booking office, extended in 1901) and Rhumbles (formerly the stationmaster's house); and Nos 1 (Honeysuckle Cottage) and 2 – the latter the home of a retired train driver. The occupant of Rhumbles, an expert on the station's history, secured Grade II listed status for the buildings in 2000.

In today's picture (taken on 14 March 2017), Class 455/8 No. 455812, one of the forty-six-strong South London 'Metro' service trains, has just arrived, forming the 17.28 service to Horsham.

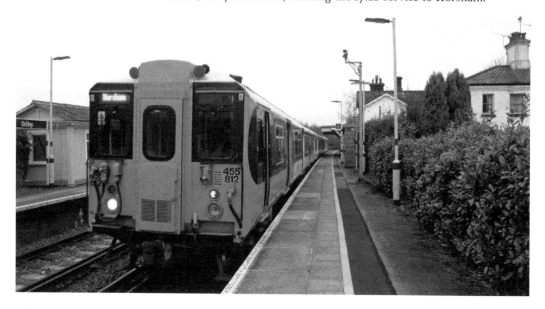

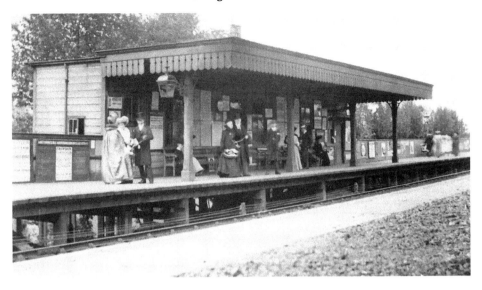

Selhurst

We now conclude the ex-LBSCR section with a look at four stations on the Brighton Main Line.

On 1 December 1862, the LBSCR opened the Balham Hill and East Croydon line, constructed as a short-cut on the Brighton Main Line to London Victoria, avoiding Crystal Palace and Norwood Junction. Selhurst Station, however, was not opened until nearly two and a half years later, on 1 May 1865. The rails were double-track until quadrupling to Balham in 1903, in which year a spacious station was provided. Today, Selhurst's massive rolling stock maintenance depot is located to the east of the station.

No vestige remains of our charming period piece above, access to this 'fast' platform (No. 4) being prohibited and fenced off. The anti-suicide barrier is evident in our modern photograph, which shows the replacement canopy on Platforms 2 and 3 fitted during the station's refurbishment in 2011 and a Victoria–Epsom Downs service timed at 11.47 on 18 February 2017 at Platform 1.

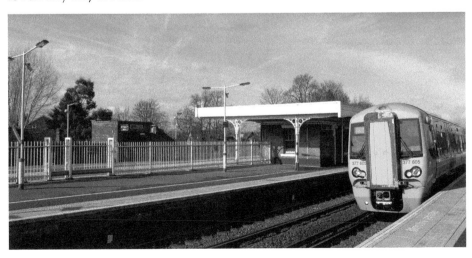

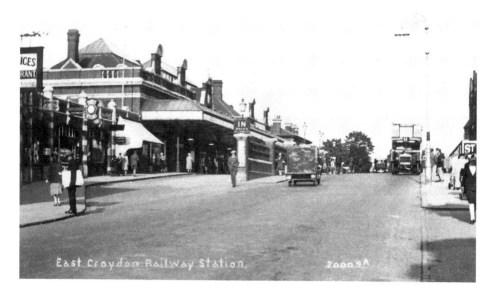

East Croydon Railway Station.

2000 9A

East Croydon

This is the busiest of the three Croydon stations and an important junction. Built to the design of David Mocatta by the London & Brighton Railway, it opened in 1841 as 'Croydon', linked to London Bridge. A second, adjacent, station (named 'New Croydon') was created as a terminal for West London suburban services once the line to Victoria was completed between 1860 and 1862.

With the rebuilding of 1894/95, the stations were merged. The three island platforms are today all served by a footbridge and long ramps.

The station name has been 'East Croydon' since 1924 (although in late 2014 plans were made for a renaming to 'Croydon Central'). The present station buildings date from 1992 but massive further refurbishment has taken place since then with, for example, a new footbridge, officially opened in December 2013. East Croydon is also a three-platform Tramlink stop. Below, services for New Addington (left) and Wimbledon (right) serve their passengers.

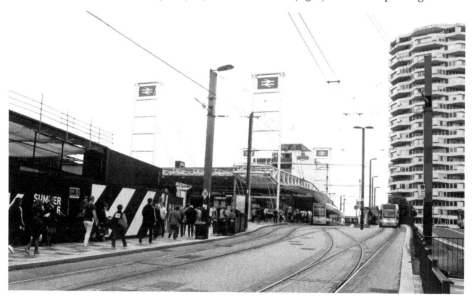

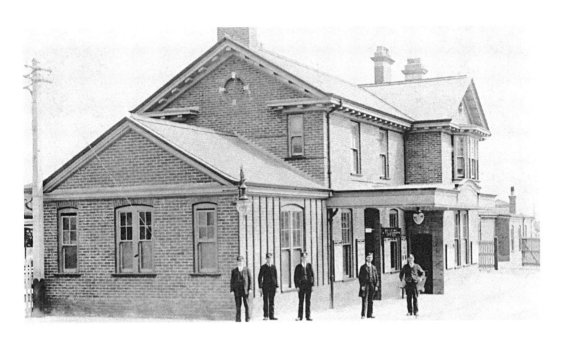

Earlswood

This station is located just over 11 miles south-southwest of East Croydon and south of the junction between the original Redhill Line and the Quarry Line of 1900 from Coulsdon North bypassing Merstham and Redhill.

It was opened by the LBSCR on 1 August 1868 and rebuilt in 1900–05 with four platforms at the time of the quadrupling to accommodate the Quarry Line, following which a subway was provided. The platforms on the fast lines, now fenced off, were closed in the 1980s and only remnants remain.

A year after the station opened, a siding was laid on the east side by the nearby Earlswood Asylum for Idiots and Imbeciles for supplies of coal and other necessary goods. It was lifted in 1964. The asylum became the Royal Earlswood Hospital, which closed in 1997.

The two-storey Domestic Revival station building, partly used as a residence, dates from 1905 and is locally listed.

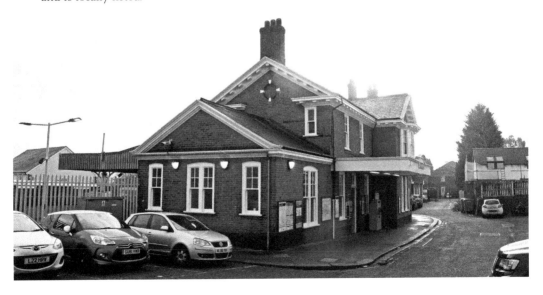

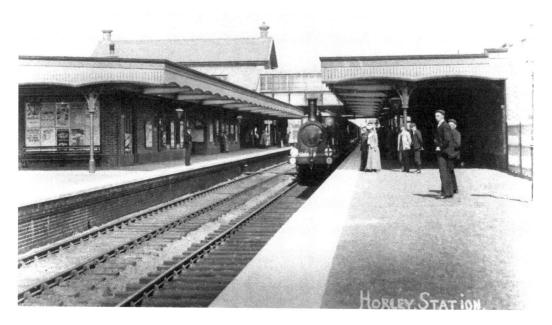

Horley (2)

Without stopping at Salfords, the intermediate station, we reach Horley, 4 miles south of Earslwood.

The 1841 station was examined on page 16, which also featured the front of the 1905 station building whose roof we see above.

The railway has undoubtedly influenced the growth of the town. When it reached here, the population stood at over 6,000; this rose to over 10,000 when the new station was opened and by 2011 (with the proximity to Gatwick Airport another major factor) the figure was 22,076.

In our early view, which dates from 1906/07, all the passengers on the Quarry Line, or Down main, platform are more interested in the photographer than the G class Stroudley-designed 2-2-2 and its train.

The station interior has seen little change down the years, save for the removal of the canopy from Platform 4. In today's view, a non-stop Littlehampton-bound train approaches that platform at 11.57 on 6 January 2017.

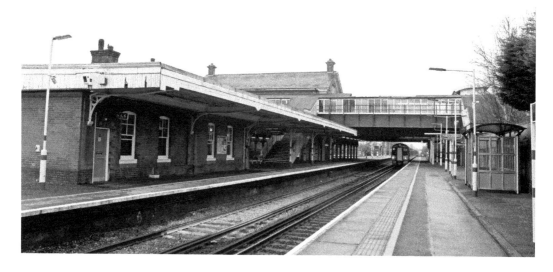

Wimbledon to Haslemere (via Guildford)

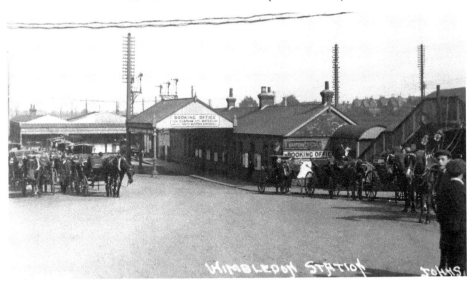

Wimbledon

In this final section, on former LSWR stations, we journey 17 miles north from Horley to Wimbledon, whose station was not only among the earliest in the county (1838) but now, with eleven platforms, is the only one in the London area to provide an interchange between national rail (South West Trains and Thameslink), the Underground (District Line) and Tramlink (Route 3) services. Between 2011/12 and 2015/16, national rail passenger use rose by 12.1 per cent (from 18.24 million to 20.44 million) and Underground patronage by 31 per cent (from 11.95 million in 2012 to 15.63 million in 2015). All a far cry from 1838, when the first station was opened to the south of the current one on the opposite side of Wimbledon Bridge and the LSWR opened its line from its terminus at Nine Elms to Woking. Our views show the LSWR's second (1880s) station in the 1900s and today's (rebuilt 1927–30), with taxis queued in Orinoco Lane.

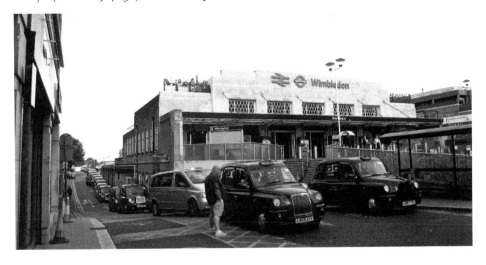

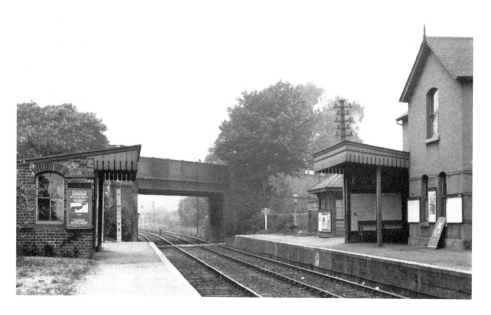

Haydons Road

Before visiting stations south-west of Wimbledon, we turn one mile north-east on the Sutton Loop Line/Wimbledon Loop to call at Haydons Road, which is unusual in having a road bridge serving as a footbridge (*although see Dormans on page 50*). The significant decrease in passenger entries and exits between 2014/15 and 2015/16: from 0.562 million to 0.400 million (-29 per cent), is an unwelcome development.

Like Merton Park (*see page 21*), the station was opened – originally as 'Haydens Lane' – by the Tooting, Merton & Wimbledon Railway, itself jointly owned by the LSWR and LBSCR, on 1 October 1868. A year later, it was renamed 'Haydons Road'. It was closed on 1 January 1917 and reopened on 27 August 1923. The station house was lost in the redevelopment of the Up platform during 1991 and 1992, being supplanted by part of Regent Place.

Below we see the approach of Thameslink's 16.30 service to Luton on 29 September 2016.

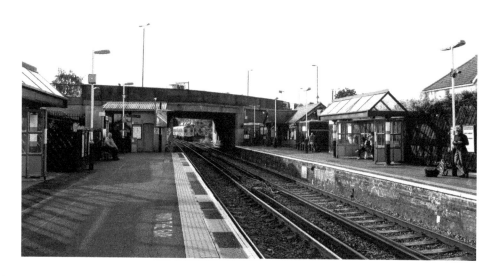

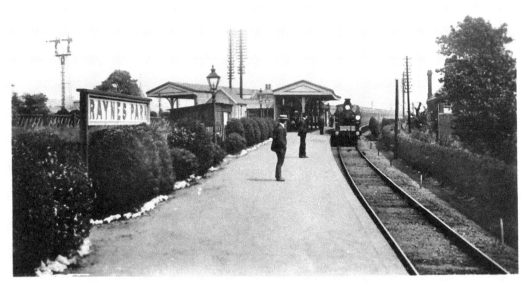

S 2889 RAYNES PARK STATION, SOUTH WESTERN RAILWAY.

Raynes Park

This is the first station reached after returning from Haydons Road to Wimbledon and proceeding south-west on the line to Woking. Our comparative views of today's Platform 4 serving the line to Epsom (or Chessington South) via Worcester Park give the impression of a quiet country station, but this belies all the action taking place in the background on the left, where today the three platforms handle approximately 210 Waterloo trains daily, averaging about twelve per hour during service hours. The stations served include Guildford, Dorking, Chessington South, Hampton Court and Shepperton, plus there are two central fast tracks on the main line which need no platforms.

The station, which dates from 30 October 1871, possesses a distinctive footbridge spanning all four main running lines at an angle of about 45 degrees. Refurbishment took place in 2009, when the station received a new entrance, ticket office, gateline and automatic ticket gates at all the exits.

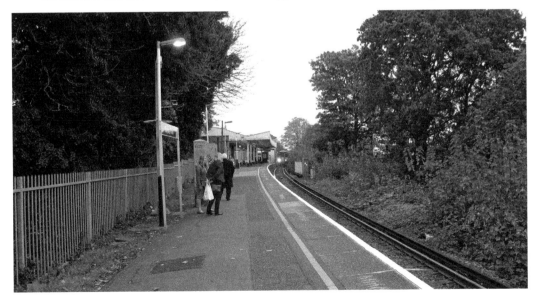

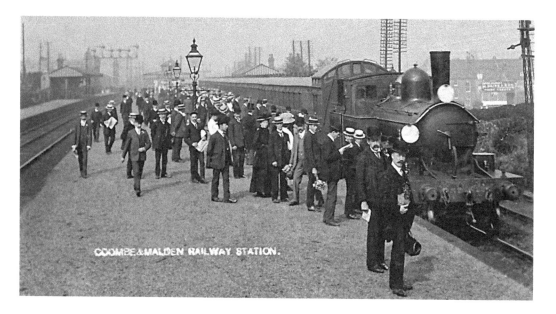

COOMBE & MALDEN RAILWAY STATION.

New Malden

The next stop towards Woking is New Malden, seen above in around 1910, with the Up main platform (closed Platform 3 today) well patronised by commuters. Today this abandoned through platform is overgrown with weeds. Some small shrubs may be survivors from flowerbeds. Only two large, colourful advertising hoardings brighten up the platform's unkempt appearance.

On Platform 1 in the background below, a Waterloo-bound Class 455 South West Train calls for its passengers at 16.10 on 28 October 2016.

The station, opened as 'Malden' by the LSWR in 1846, underwent various name changes down the years (*see the above image, for example*).

The town suffered an air raid on 16 August 1940, which resulted in fifty-seven casualties. It destroyed shops, over 1,300 houses, and the New Malden Baptist Church. At the station, a porter and the station inspector were killed, the booking office and a stairway were hit, and arriving passengers from a Wimbledon–Kingston train were machine-gunned by low-flying aircraft.

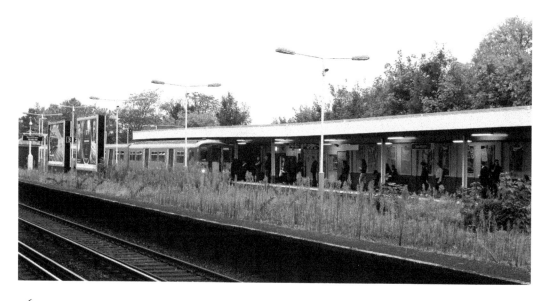

Kingston

Turning north-west from New Malden, on the line to the Shepperton branch and Twickenham, we pass through Norbiton station and arrive at the station serving the Royal Borough of Kingston upon Thames. The fine early view above shows the building occupying the same site as it does today, on the corner of Wood Street and Richmond Road.

As the terminus of the LSWR's branch line from Twickenham, it had opened on 1 July 1863 as 'Kingston New' (or 'Kingston Town') to distinguish it from the earlier Kingston station (which became Surbiton!) on the South West Main Line. When the line was extended in 1869 to connect to that line, the platforms built were named 'Kingston High Level'. The stations were amalgamated by the Southern Railway in 1935 and renamed 'Kingston'.

Today, platforms 1 and 2 serve Teddington, Twickenham, Richmond, Putney and Shepperton, and Platform 3, Wimbledon, Clapham Junction and Waterloo. Refurbishment was carried out in 2010.

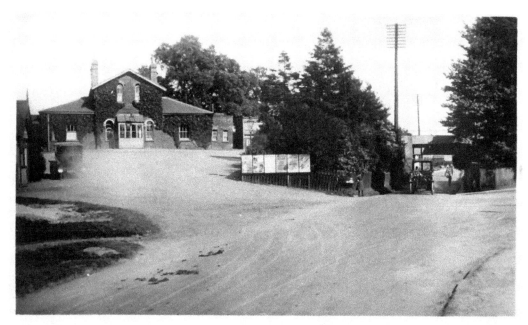

S 12494 L. S. W. RLY. STATION, WORCESTER PARK.

Worcester Park

Three miles south-east of Kingston, this is the first of two stations on the line from Raynes Park to Epsom we shall be visiting before returning to the Wimbledon–Woking main line. Originally named 'Old Malden', it opened in 1859 with the LSWR's Epsom branch. It was renamed 'Worcester Park' in 1862. The pleasing, ivy-clad station building depicted above, residential in appearance, was replaced in characteristic utilitarian style by the Southern Railway in the early 1930s in response to substantial local housing development. A directly matching pair of images is impossible to achieve today.

The dusty, near-deserted highway from Cheam we see above, which passes under the (since rebuilt) railway bridge on the right, is today the traffic-laden Central Road on the A2043; nor is the forecourt area, Station Approach, normally as quiet as the picture below suggests.

Within the station, a new passenger bridge equipped with lifts was opened in June 2014.

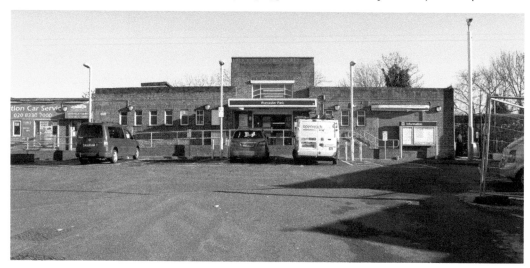

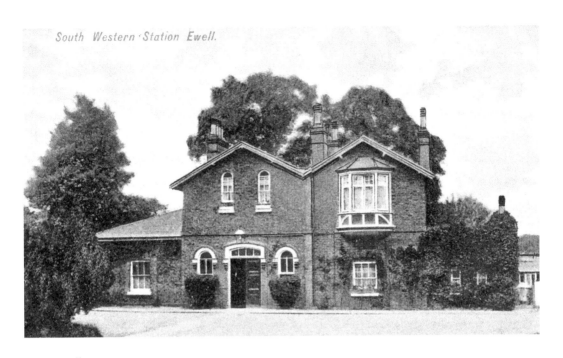

South Western Station Ewell.

Ewell West

This Grade II-listed neighbour and contemporary of Worcester Park Station was spared a rebuild and was, interestingly, the site, from 1905 to 1950, of exchange sidings with a standard gauge railway constructed initially to transport the materials for the building of Long Grove Hospital, completed in 1907. This was one of the 'Epsom Cluster' – London County Council's group of ultimately five large psychiatric hospitals in the Horton Lane area, three of which had opened by 1904. The original 1905 railway, dismantled after Long Grove was opened, was re-opened with some route differences in May 1913 as the Horton Estate Light Railway, mainly to serve the Cluster's power station as well as Long Grove and, later, West Park Mental Hospital, which officially opened in 1924.

The HELR, much of whose route lies today within Horton Country Park, was closed in January 1950 and all the hospitals, except St Ebba's and part of West Park, have themselves closed.

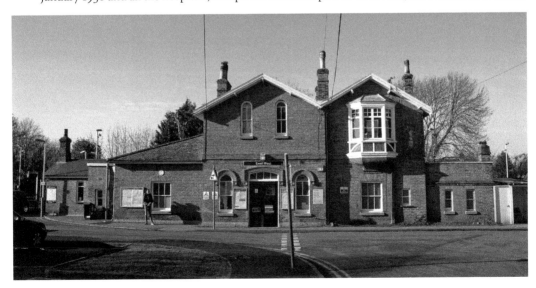

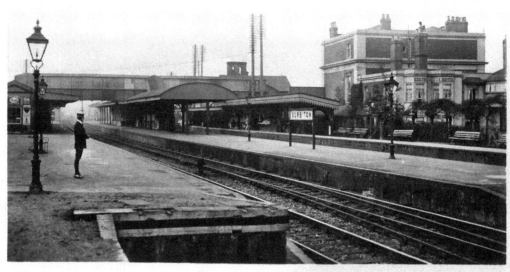

S 6691 SURBITON STATION L &. S. W RLY.

Surbiton

Four miles north-west of Ewell West stands Surbiton Station, opened as early as 1838 under the name 'Kingston-on-Railway'. Seven years later it was resited 700 metres west. It was renamed 'Kingston Junction' (1852) and 'Surbiton and Kingston' (1863) before finally being named 'Surbiton' (1867).

The station was wholly rebuilt in 1937–38 in modernist style, the lead designer being James Robb Scott (1882–1965). Scott designed a string of railways stations, including Horsham, Hastings, Richmond and Waterloo Station and offices, but this was his masterpiece.

Now a Grade II-listed building, Surbiton was voted Britain's 'most improved station' after its £3 million refurbishment in 1998.

In the early view above, the Southampton Railway Hotel is prominent. It was demolished in 1960 and DST House now occupies the site.

Below is seen one of Network Rail's Windhoff Multi-Purpose Vehicles, YXA No. 98973, named *Chris Lemon*, assigned to leaf-blowing duties on 3 November 2016.

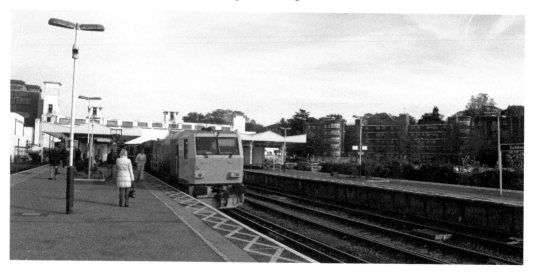

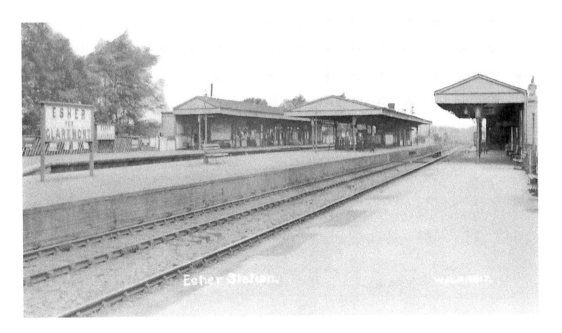

Esher

At Esher Station, 2 miles south-west of its neighbour, Surbiton, we have the same unsightly overgrown island through platforms as at New Malden, although maintenance would admittedly be pointless.

The name first applied to the station when it opened in 1838 was 'Ditton Marsh', changed two years later to 'Esher and Hampton Court', then 'Esher and Claremont' (1844) and finally 'Esher' (1913). Note the variant 'Esher for Claremont' in the early view above, which also illustrates the former extent of canopy cover.

The station, elevated above street level, serves Sandown Park Racecourse, which opened in 1875. A special gate on one of the platforms opens directly onto the course, particularly on major race days. Until October 1965, an extra three platforms, connected by a subway to the racecourse, were available for use on such days.

Below, a Class 450/0 EMU approaches Down local Platform 4 at 13.17 on 21 January 2017.

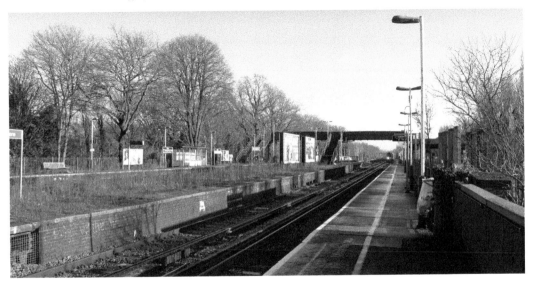

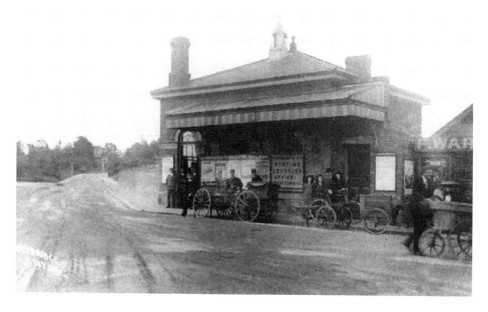

Weybridge

Weybridge's 1838 station, of which nothing survives, was constructed in a deep cutting. Our image from around 1910 shows the booking office at the top of a tower at upper road level, with the bridge on the left, from the costly 1857–60 rebuild (of which the building with distinctive arched doorways and windows at Up platform level is a further survivor). The Post Office workers and carts are explained by the premises having been leased some years previously to the GPO. In the 1930s, the building became the Shanty Café and remained so for over forty years, before being smartened up to become Buffers Restaurant. The extension on the right in the attractive 2009 photo below dates from 1992 to 1993 when the premises were being run as a nightclub, the Noir Bar.

Further rebuilds of the station took place in 1904 and 1922, with refurbishments later in the century.

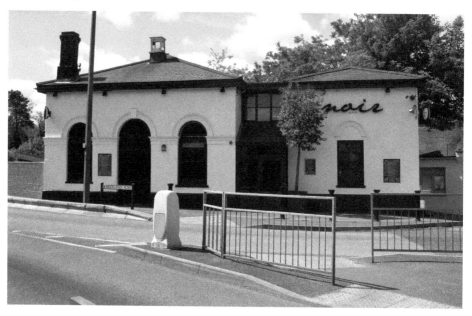

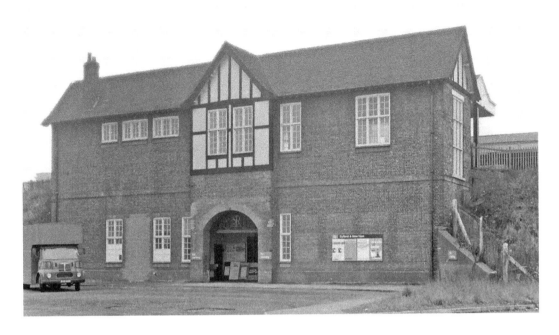

Byfleet & New Haw

This is the second-youngest station in Surrey (after West Sutton) recorded in this volume, having opened as late as 1927 in response to local population growth. Well before the station opened, there had been substantial residential expansion in the area, with the opening of the Vickers aircraft factory in 1911 leading to Byfleet's population doubling in just ten years.

Built as 'West Weybridge' to the design of James Robb Scott, responsible for, inter alia, the stations at Wimbledon, Surbiton, Richmond and Waterloo railway station offices and, away from the railways, Victory Arch at Waterloo Station, it stood – like Weybridge Station – in close proximity to the legendary Brooklands racing circuit, which hosted races from 1907 until the Second World War and has, since 2006, been the site of Mercedes Benz World and a local community park.

The station name was changed to 'Byfleet and New Haw' on 12 June 1961.

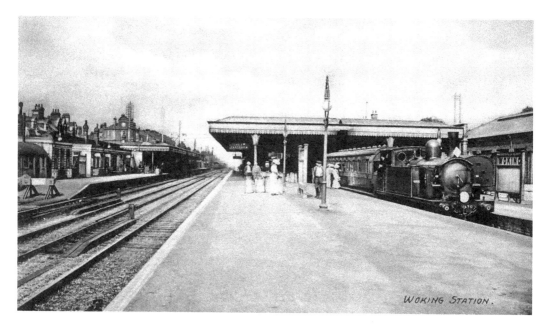

WOKING STATION.

Woking

H. G. Wells lived here in 1895–96 and although he destroyed the station in his *The War of the Worlds* (published in book form in 1898), it is happily very much still with us today. One of the busiest stations in the county, it started life as 'Woking Common' in 1838, its name being changed in 1845 to 'Woking Junction' (retained until 1913) to reflect the opening of the Guildford Junction Railway in that year. However, 'Woking' was widely used down the decades – as above, where we see a stopping train at the Down loop platform headed by LSWR Class T1 0-4-4T No. 70, built in 1889. Below, southbound Class 159/0 DMU No. 159014 stands at Platform 2 on 24 September 2016.

Dominating the skyline on the left is Albion House, a large 1960s office and mixed-use development currently undergoing a makeover under redevelopment plans for the area, which includes the station's north/west entrance.

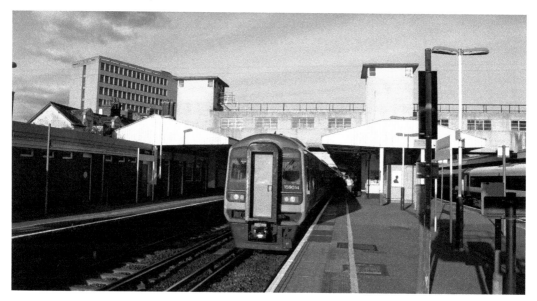

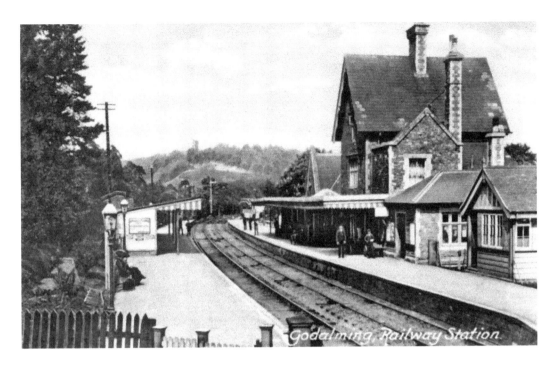

Godalming

Leaving Woking 10 miles to the north-east behind us, we arrive at the attractive and multi-award winning station of Godalming, between Guildford and Havant on the Portsmouth Direct Line. The station opened on 1 January 1859, replacing the original single platform terminus of 1849 located on a spur just south of neighbouring Farncombe station. The elegant stone-faced, three-storey station house, built in a mock Tudor style and in residential use, is Grade II listed and the work of William Tite (1798–1873), best-known for the rebuilt Royal Exchange, London, opened in 1844. His numerous railway designs include the Surrey stations of Kew Bridge and Hampton Court.

In 2016 the station was allocated £3.1 million of funding, under the government 'Access for All' programme, for refurbishments that included replacing its damp and dilapidated subway by a fully-enclosed footbridge equipped with two sixteen-person lifts to enable step-free access between platforms.

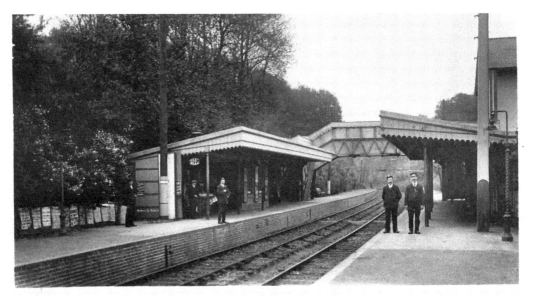

S 8939 L. S. W. RLY STATION WITLEY.

Witley

Like neighbouring Milford to the north-east, Witley Station, opened as 'Witley and Chiddingfold' and renamed simply 'Witley' on 6 October 1947, is a minor stop on the Portsmouth Direct Line.

As at Haslemere (*see next page*) and Ewell West (*page 79*), the station house is a two-storey redbrick Italianate building containing the – here closed – ticket hall on the ground floor, flanked on each side by hipped lean-to pavilions. The station frontage area includes a car park, a disused stone-built hut, partly ivy-covered, the property of Network Rail, and another small stone, slate-roofed building providing refreshments. The gentlemen's convenience on Platform 2 and the waiting room on Platform 1 were both closed when the station was visited on 23 October 2016.

In Brook Road, the imposing residence 'The Heights' was purchased in December 1876 by the novelist George Eliot (1819–1880) and lived in by her, albeit not continuously, until her death four years later.

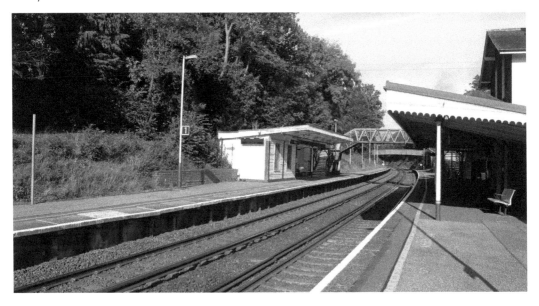

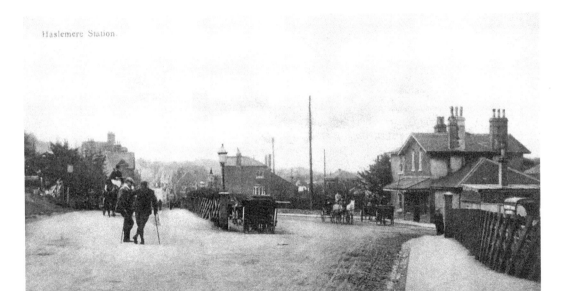

Haslemere

The railway history of Haslemere, whose busy station is the last on the Portsmouth line within the county, is tainted by a tragic incident. On 29 July 1855, three and a half years before the station opened, Inspector William Donaldson was fatally injured during a drunken assault on the police station by a group of navvies. He was the first Surrey police officer to be killed while on duty.

Happier local memories are displayed in the railway station booking office, where early framed photographs depicting the station frontage and interior and dating from 1910, 1913 and 1925 adorn the walls.

Unusually for the line, the station boasts three platforms – the third, creating an island platform, having been built in 1938 when the line was electrified. Other refurbishments took place at that time under the overall development scheme of 1937. Improvement in recent years includes the provision of a new footbridge (2008) and a new decked car park (2016).

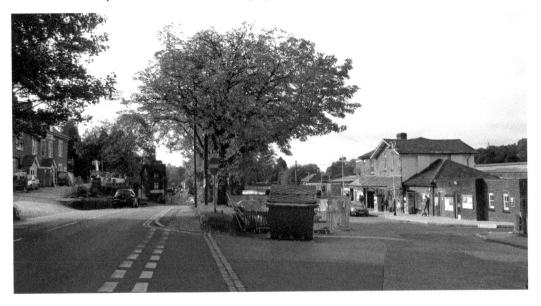

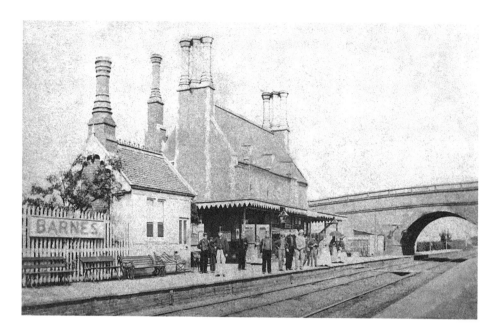

Barnes

A journey of 33 miles north-eastwards from Haslemere brings us to Barnes, depicted above in a valuable photograph by A. & E. Seeley, who had their studio in Greville Road, Richmond, in 1866–1867.

The design of this Grade II-listed station house for the opening of the line, the Richmond Railway, in 1846, has been described as 'Tudoresque Gothicism' and attributed to William (later Sir William) Tite (*see Godalming, page 85*), but original documentary evidence is lacking. The station houses at Putney and Mortlake were similar, but much smaller. Today, the ground floor (former ticket office) of this extraordinary building, owned by Anne Marshall, is leased by Penham Portfolio Management while the upper floor has for several decades been the residence of Ms Marshall and her husband, prominent blues musician Papa George.

When the first section of the Hounslow Loop Line was opened on 22 August 1849, Barnes became a junction station.

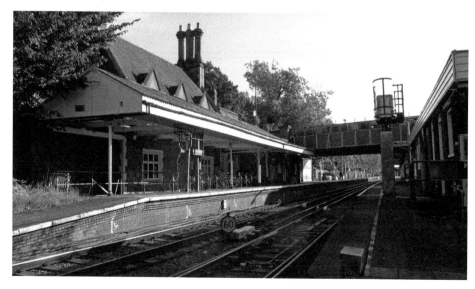

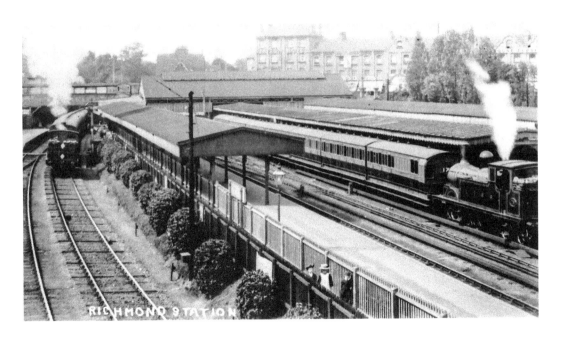

Richmond

This seven-platform station, the third stop westward from Barnes, is one of Surrey's busiest. The original 1846 station opened by the Richmond & West End Railway (R&WER) stood to the south of the present through platforms. The site became a goods yard and is now occupied by a multi-storey car park. Two years later, the Windsor, Staines & South Western Railway (WS&SWR) which, like the R&WER, was a subsidiary of the LSWR, re-sited the station to the west side of The Quadrant.

The station's subsequent history is one of expansion and change involving several railways. In 1937 the Southern Railway rebuilt the station in Portland stone, with a square clock incorporated into the façade, to the Art Deco design of James Robb Scott (*see Surbiton, page 80, and Byfleet and New Haw, page 83*).

Adjoining the station's north side is Westminster House, a large 1950s commercial block, with shops below, whose two-storey rooftop extension is currently being planned.

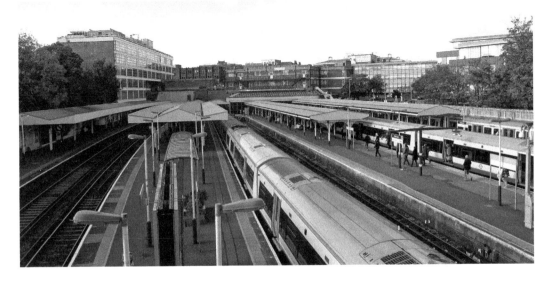

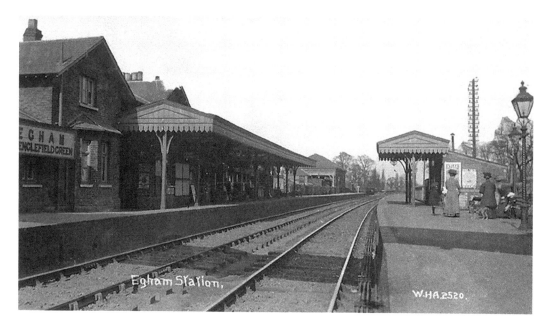

Egham

Eleven miles south-west of Richmond Station as the crow flies is Egham Station, opened by the Staines, Wokingham & Woking Junction Railway on 4 June 1856, simultaneously with the other five stations on that company's Staines–Ascot stretch. The SW&WJR then opened the stations onwards to Wokingham just over a month later, on 9 July 1856. The LSWR, which leased the line from the owning company in 1858 for 50 per cent of the gross profits, operated the line from the outset, purchasing it outright in 1878. When the railway came, Egham was a sleepy village and coaching hub. Its station building, demolished in 1972, was finally replaced in 1985 by a structure with a futuristic metal roof. A large number of students from London University's Royal Holloway College use the station, hence the college name below the station's own on the nameboards.

Of the two footbridges, the rusty one beside the level crossing is a poor advertisement for the station.

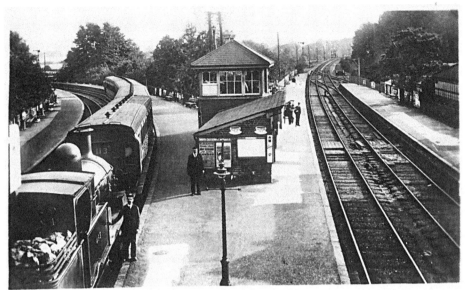

VIRGINIA WATER STATION

Virginia Water

Virginia Water, the next station south from Egham, received a new prefabricated concrete building from British Rail in 1973, as did Wokingham and Sunningdale.

In common with Egham, its platforms were extended in April 2017 as part of an £800 million investment in the railway running into London Waterloo so that it could accommodate the longer ten-car trains that South West Trains began operating on the route from May 2017.

In the nostalgic early photo of the station above, a tank numbered 463 waits at Platform 3 serving the Chertsey Branch Line, while in the picture below, taken on 5 November 2016, Waterloo-bound South West Trains 'Juniper' Class 458 No. 458528 approaches the same spot. Today, in place of the signal box and refreshment kiosk prominent above, may be seen one of the lift towers for the footbridge scheduled for completion in June 2017.

On the right, Platforms 1 and 2 are used by services to and from Reading.

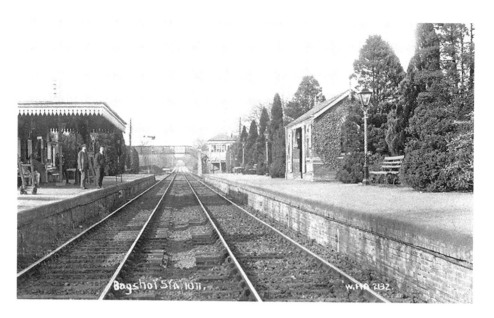

Bagshot

Leaving Virginia Water by the Reading line and turning south from another junction, Ascot, we reach the first of two adjacent stations that bring our journey to an end – namely Bagshot and Camberley. These, with seven other stations, serve the Ascot–Guildford line, opened by the LSWR on 18 March 1878.

The main buildings at both stations, featuring barge-boarded pavilions at either side with distinctive valancing and a canopied central block, were identical (and very similar to Frimley's) until 1975 when Camberley's was totally rebuilt (*see overleaf*). At Bagshot, much of the former booking hall and ladies' convenience has been put to successful commercial use since 2013 by the 'Hair for Men Academy'. The ticket office is manned only in the mornings. The ivy-clad waiting shelter on Platform 2 with an ornate window arch on both sides in the above image has survived, windowless.

Below, an approaching two-car South West Trains Class 456 unit forms the 15.59 service to Guildford on 17 January 2017.

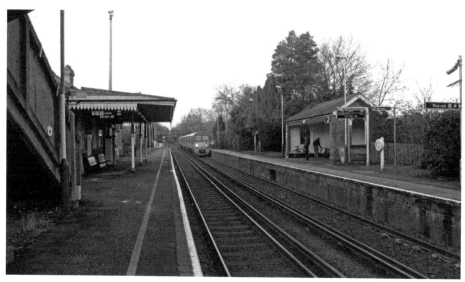

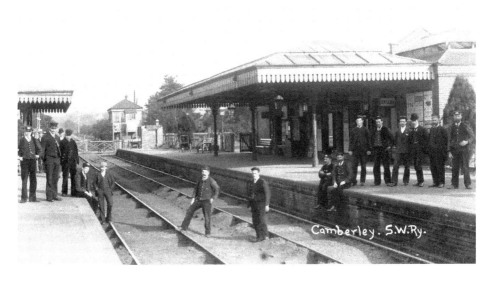

Camberley

When built, Camberley Station (named 'Camberley and York Town for Sandhurst' until 9 July 1923) was, as noted, a 'twin' of Bagshot's and closely resembled adjacent Frimley's. All that changed in 1975–77 with the building of the three-storey Station House, which incorporated a new station entrance under part of its first floor, leading into a separate glass-walled, flat-roofed structure housing the ticket office, staff rooms, a shop and a waiting area. Station House is currently the regional office of Accent Peerless Ltd, owners and managers of social housing nationwide.

Above, postcard publisher Ernest Pouteau (1863–1932) of Gray's Inn Road, London, has left us a remarkable record of the station interior and staff over a century ago, with the long-vanished signal box beyond the level crossing gates. Below, by great contrast, may be seen Station House, the utilitarian shelters for passengers on the platforms and, in the distance, the station's distinctive footbridge.

Select Bibliography

Conolly, W. P. (Ed.),	*British Railways Pre-Grouping Atlas & Gazetteer*, New 6th Edn (Hersham, 2015)
Burgess, N.,	*Surrey's Lost Railways* (Catrine, nd.)
Butt, R.V.J.,	*The Directory of Railway Stations* (Sparkford, 1995)
Clarke, J. M.,	*The Brookwood Necropolis Railway* (Usk, 1983)
Dann, C. E.,	*Surrey Steam* (Kings Lynn, 1983)
Gough, T.,	*British Railways Past and Present – Surrey and West Sussex Past and Present* (Peterborough, 1993)
Gough, T.,	*Surrey – the West of the County* (Kettering, 2002)
Gough, T.,	*Surrey – The East of the County, Past and Present* (Kettering, 2003)
Gray, A.,	*The London to Brighton Line, 1841–1977* (Tarrant Hinton, 1977)
Harding, P. A. & Clarke, J. M.,	*The Bisley Camp Branch Line* (Woking, 1986)
Harrod, John T. A.,	*Up the Dorking*, Southern Railways Group (Windsor, 1999)
Hayes, Oliver,	*How the Steam Railways came to Surrey* (Epsom, 2015)
Jackson, Alan A.,	*The Railway in Surrey*, Atlantic Transport Publishing (Cornwall, 1999)
Jeffs, S.,	*The London to Brighton Line* (Stroud, 2013)
Marsden, Colin J.,	*Rail Guide 2016* (Hersham, 2016)
Marx, Klaus,	*London Brighton & South Coast Railway Album* (Shepperton, 1982)
Oppitz, L.,	*Lost Railways of Surrey* (Newbury, 2002)
Owen, N.,	*The Tattenham Corner Branch* (Tarrant Hinton, 1978)
Pryer, G. A. & Bowring, G. J.,	*An Historical Survey of Selected Southern Stations, Volume 1* (Poole, 1980)
Smith, J. D.,	*Weybridge Station* (Weybridge, 2003)
Wikeley, N. & Middleton, J.,	*RAILWAY STATIONS – Southern Region* (Seaton, 1971)

Especially valuable were the following books by Vic Mitchell and Keith Smith, all published in Midhurst:

London Suburban Railways – Lines around Wimbledon, 1996; *Country Railway Routes – Croydon, Woodside to East Grinstead*, 1995; *London Suburban Railways – Caterham and Tattenham Corner*, 1994; *Southern Main Lines, East Croydon to Three Bridges*, 1988; *Southern Main Lines – Epsom to Horsham*, 1986; *Branch Lines around Effingham Junction*, 1990; *Country Railway Routes – Guildford to Redhill*, 1989; *Branch Lines to Horsham*, 1982; *London Suburban Railways – Mitcham Junction Lines*, 1992; *London Suburban Railways – Wimbledon to Epsom, including Chessington Branch*, 1995; *Branch Lines to Tunbridge Wells*, 1986; *Southern Main Lines – Victoria to East Croydon*, 1987; *London Suburban Railways – West Croydon to Epsom, including the Epsom Downs Branch*, 1992; *Southern Main Lines – Waterloo to Woking*, 1986.

Online sources:	Wikipedia pages covering individual stations
	Disused stations site (http://www.disused-stations.org.uk/)
	www.sheredelight.com
	www.TheCaterhamRailway.co.uk
	Home pages of various other community/local history/ railway-related societies, groups and associations.
	Miscellaneous online maps, especially those at http://maps.nls.uk/

Acknowledgements

Many people and organisations willingly assisted me, both in person and online, in my research for this book and they are gratefully acknowledged here. Those who helped in connection with particular stations have the station name(s) concerned shown within brackets after their own names:

Hugh Anscombe, Secretary, Surrey Industrial History Group (Woking); Brian Buss, Horley History Society (Horley); Richard Christophers, Woking History Society (Woking); Rupert Courtenay-Evans, Chipstead Village archivist (Chipstead); Peter Cox, Horley History Society (Horley); Alberto Crisci MBE (Epsom Downs); Andy Davidson (Coulsdon North); Szilvia Ghavimi (Epsom Downs); Amy Graham, Kingston History Centre; Tristan Greatrex (Gomshall & Shere); Deborah Healy (Bagshot); Mike Jones (Box Hill); Alan Keys (Barnes – photo restoration); Nick Knight (Chipstead); Jay Marshall, formerly with About Roofing Supplies (Dorking West); Peter Mattey, Belmont & South Cheam Residents' Association (Belmont); Roger Packham (Caterham); George Papanicola (Barnes); Chris Parker (Caterham); Barry Pepper (Chipstead); Jeff Richardson (Dormans); Mark Smith, Proctor & Co. Ltd (Kenley); Simon Strudwick, Biwater Holdings Limited (Dorking); Bozena Tomasik (Barnes); Peter Townsend, Silver Link Publishing Ltd (Dorking West); Howard Webb (Wimbledon and Barnes); Nicholas Winfield, Epsom & Ewell Local and Family History Centre (Epsom (ex-LBSCR)/ Epsom Town, Epsom, Ewell West); Jason Wright (Ockley); Adrian Wymann (Belmont and Banstead); Kathryn Woodham, The Interior Workshop (Woldingham).

As in the case of the Picture Credits, sincere apologies are owed to any person or organisation inadvertently omitted.

Finally, I should to thank friend, neighbour and transport enthusiast Chris Wrapson, photographer and railway author Phil Barnes, and local historian Chris Horlock for their support and encouragement during the preparation of this volume.

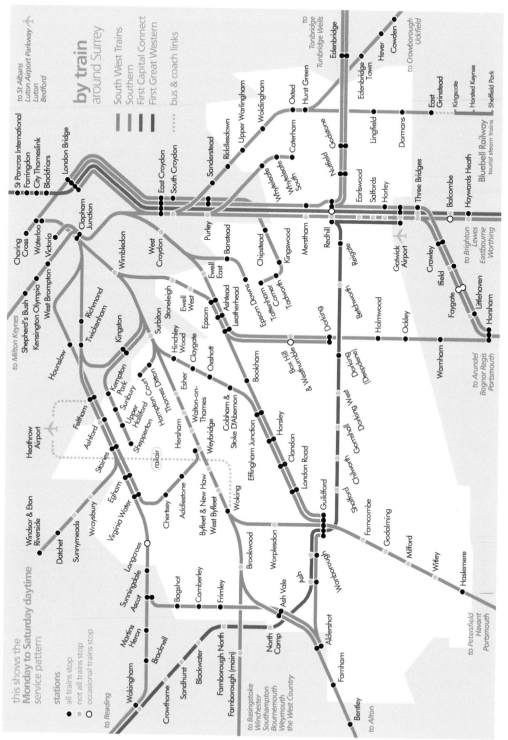

'By Train Around Surrey'. Map produced by Surrey County Council illustrating the county's present railway network.